# A History of Cadbury

# A History of Cadbury

Diane Wordsworth

PEN & SWORD
HISTORY

First published in Great Britain in 2018 by
Pen & Sword History
An imprint of
Pen & Sword Books Ltd
Yorkshire – Philadelphia

HB ISBN: 9781526733375
PB ISBN: 9781526751669

A CIP catalogue record for this book is
available from the British Library.

Printed and bound in the UK by TJ International Ltd,
Padstow, Cornwall.

Pen & Sword Books Limited incorporates the imprints of Atlas,
Archaeology, Aviation, Discovery, Family History, Fiction, History,
Maritime, Military, Military Classics, Politics, Select, Transport,
True Crime, Air World, Frontline Publishing, Leo Cooper,
Remember When, Seaforth Publishing, The Praetorian Press,
Wharncliffe Local History, Wharncliffe Transport, Wharncliffe True
Crime and White Owl.

For a complete list of Pen & Sword titles please contact

PEN & SWORD BOOKS LIMITED
47 Church Street, Barnsley, South Yorkshire, S70 2AS, England
E-mail: enquiries@pen-and-sword.co.uk
Website: www.pen-and-sword.co.uk

Or

PEN AND SWORD BOOKS
1950 Lawrence Rd, Havertown, PA 19083, USA
E-mail: Uspen-and-sword@casematepublishers.com
Website: www.penandswordbooks.com

# Contents

# Acknowledgements

A very quick thank you to all who have helped with the production of this book, with special thanks to Sarah Foden, Jackie Jones and Sarah Welch at Cadbury Archives and Mondelēz International, everyone at Pen & Sword, and finally to my husband Ian, for both his support and for taking some of the photographs.

Where possible, every effort has been made to trace the copyright holders and obtain permission to reproduce the photographs that appear in this book. When this has not been possible, the author would be glad to hear from copyright holders so that due credit can be given in future printings.

# Foreword

Compressing 200 eventful years of the history of the Cadbury firm into such a slim volume was always going to be a challenge for any author. Very wisely Diane Wordsworth's book focuses on the development of the business over the first 100 years and the roles of Richard and George Cadbury. They laid the foundations of the enterprise taking it over from their father John when it was verging on bankruptcy and building it up as a leader in their field of cocoa and chocolate products with the eponymous Cadbury's Cocoa Essence, later to be reformulated as Bournville Cocoa, and Cadbury's Dairy Milk Chocolate brands.

In the ground-breaking move of their factory from the centre of Birmingham to the countryside they named Bournville, they developed the 'factory in the garden' concept and became as famous as pioneers in employee social welfare and community philanthropy as they were for their products.

Their record in the provision of fair wages, pensions and savings schemes, educational, recreational and health facilities was unequalled at the time and the expansion of Bournville in to a garden village suburb realised George Cadbury's vision of providing an affordable alternative of houses and gardens in a clean and leafy context for those accustomed only to life in the grimy, unhealthy and dangerous confines of the Birmingham slums.

This *History of Cadbury* does not attempt to be a business case study but its rich account of the development of the business together with splendid photos and personal stories sourced from the excellent Cadbury Archive at Bournville gives a compelling authentic record of how the firm inspired universal admiration for its business practices to equal the popularity and affection for its products and brands.

Sir Dominic Cadbury
October 2018

# Introduction

*On the "Fourth day, of third month, 1824," as notified in Aris's Birmingham Gazette, and recorded in the original Day Book, John Cadbury founded the business by opening a small Warehouse, at 93, Bull Street, for the sale of Fine Teas, Spices, Freshly Roasted Coffees and Cocoa. The venture was hardly of a speculative nature, for next door, at 92, his brother, Benjamin Head Cadbury, was already established as a successful Silk Mercer and Linen Draper, in a business founded by their father, Richard Tapper Cadbury, well known as the genial, if despotic, Chairman of the Board of Commissioners, a body which then fulfilled the functions of the present City Council.*

Barrow's Stores Centenary 1824–1924

Cadbury's in Birmingham, c2018. (*© David Hughes/shutterstock.com*)

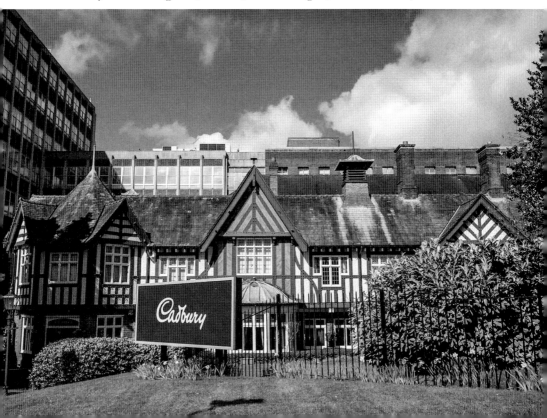

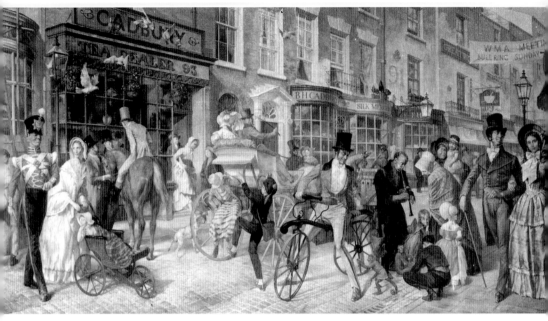

An early artist's impression of the original shop in Bull Street. (*Courtesy of Cadbury Archives and Mondelēz International*)

John Cadbury bought the shop on Bull Street in Birmingham with money given to him by his father, who owned the shop next door. Alongside tea and coffee, John also sold cocoa beans. The cocoa beans were just that, beans, but John took pestle and mortar and ground them into something that could be turned into drinking chocolate. It didn't taste very nice at first, but he soon learnt how to add things to make the drink more palatable. Drinking chocolate was seen as a healthy alternative to alcohol – something John, being a Quaker, was keen to encourage. In those early days, flour and starch were added, but later it was chicory and other flavourings and enhancements. Much later, when the business had been taken over by John's sons, it was decided to make the drinking chocolate lines more pure, and out came the cheap additives of starch and flour.

The little shop in Bull Street soon gave way to a warehouse just around the corner in Crooked Street. And when the company outgrew that premises too, and the Great Western Railway came to acquire the property for other purposes, the firm was moved to a small factory in Bridge Street, also in Birmingham. So they went from shop to warehouse

Poster advertising Cadbury's, c1890. (*Courtesy of Cadbury Archives and Mondelēz International*)

to factory in only a matter of years. By 1842, the company was selling almost thirty different types of drinking chocolate and cocoa.

Drinking chocolate has historically been made using just chocolate, whereas cocoa is quite thin and has other ingredients added to it such as sugar or sweeteners and other flavourings. Drinking chocolate, which has been described as both 'bitter' and 'rich', can be made using hot milk or hot water. Cocoa, on the other hand, is usually made with hot milk. It appears, though, that in the early days at least, Cadbury used both terms for either product and it's not clear if the two products were in fact definable in this otherwise traditional manner.

In 1861, the firm was taken over by two of John's sons, who started to grow the company into the organisation we see today. In 1875, they produced their first Easter egg, and by 1897 they were manufacturing chocolate bars. By 1879, the factory in Bridge Street was deemed unsuitable, and not just because of its small size. The location of

the factory also caused the brothers some discomfort. As committed Quakers and members of the Society of Friends, they believed in providing a workplace in pleasant surroundings away from the dirt, grime and overcrowding of what had now become a small city.

Enter the new premises at Bournville – a town that didn't even exist until the Cadburys moved their chocolate factory there. And it wasn't just a factory – it became a way of life, with green fields, habitable housing and good working conditions. Very good working conditions that any company today would be proud of.

The Cadburys as a family did much for social welfare and reform. Cadbury's as a firm did the same for their workers. Some may think the business was too patriarchal – and in today's climate they would probably be correct – but what this company did for workers' welfare in the middle of the nineteenth century and beyond should be held up as a model. The company and the family believed that a happy healthy workforce meant a happy healthy business. The fact that the firm is still here today, almost 200 years later, speaks for itself.

In 2024, Cadbury's will be celebrating 200 years of the first store opening, although they class 1831 as the start of the company we now know. This is the story of how Cadbury's began, how it grew, and how the company diversified in order to survive.

*Chapter 1*

# The Birth of a Dynasty

The Cadbury family originated in the counties of Devonshire, Dorset and Somerset, and it is from the Devonshire branch of the family that Richard Tapper Cadbury came. Richard was born in Exeter in November 1768. His grandfather, John Cadbury, was a member of the Society of Friends and he married Hannah Tapper in 1725. Hannah's father, Richard Tapper, was one of George Fox's converts to Quakerism. He was imprisoned in Exeter Gaol for this in 1693. Hannah Tapper and John Cadbury were the parents of Joel Cadbury, who married Sarah Moon as his second wife. Richard Tapper Cadbury was their son.

Richard Cadbury left Exeter in 1782 when he was 14. He went to Gloucester, where he was apprenticed to a draper. When his apprenticeship ended, he moved to London where he lived with linen drapers Jasper and Ann Capper:

> *In my nineteenth year I received wages of £20 per annum, out of which I respectably clothed myself, found my washing and pocket money, and always appeared so respectable as to be the invited guest amongst the first families of Gloucester. My wages gradually advanced to £40 per annum; I then lived in London at Jasper Capper's and was 24 years of age. During that six years I not only maintained a respectable appearance, but in many cases was enabled to be generous, and purchased many books amongst which is Rees Encyclopedia, now in the book case. I may add that during that period I do not remember receiving 1s. from my father, and knowing that he was not opulent – having in the course of his life met with many losses and sustained many difficulties – it was delightful to me to reflect I had no need to press upon him, and made indeed very sweet the reflections instead of the many gratifications I deprived myself of.*
>
> Richard Tapper Cadbury, *The Firm of Cadbury: 1831–1931*

In 1794, Richard moved to Birmingham with his friend Joshua Rutter and in June of that year an associate of the two young men wrote to Matthew Boulton, an English manufacturer and business partner

Poster advertising Cadbury's, by Cecil Aldin, c1902. (*Courtesy of Cadbury Archives and Mondelēz International*)

of the Scottish engineer James Watt, singing their praises and recommending them very highly. The friends set-up in business in Birmingham as drapers, and in 1798 Richard acquired a property in Bull Street in the town centre as both his residence and his place of business. This property was at 85 Bull Street, but was later re-numbered 92 Bull Street. Meanwhile, in 1796, Richard married Elizabeth Head, with whom he had ten children. The eldest of these, Sarah, was born at a house in Old Square, but all the others were born at Bull Street.

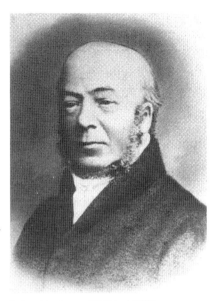

John Cadbury (1801–1889).
(*Courtesy of Cadbury Archives and Mondelēz International*)

Benjamin Head Cadbury, Richard and Elizabeth's eldest son, was born in 1798. John, the third son, was born in 1801. A second son, Joel Cadbury, was born in 1799, and it was he who emigrated to the United States and founded the American branch of the family.

Richard Tapper Cadbury retired from his drapery business in 1828. His son, Benjamin Head Cadbury, continued with the business for a while with another brother, James, before joining his younger brother John.

## John Cadbury (1801–1889)

Our story begins in March 1824, when John Cadbury opened his shop in Bull Street, Birmingham, selling tea.

In 1816, Richard Tapper Cadbury apprenticed his son John to a fellow Friend, John Cudworth, of Broadhead and Cudworth in Briggate, Leeds. Here John learnt about the retail business and tea-dealing. In 1822, he went to London for a year, where he gained further experience with the firm of Sanderson, Fox and Company. When John returned, his father gave him a sum of money with which he could 'sink or swim'. John chose to swim and on 4 March 1824 he opened his own shop at 93 Bull Street.

In the early days cocoa and chocolate were not such a large part of John's business as tea-dealing and coffee-roasting were so, at first, the shop concerned itself with the sale of tea and coffee. But cocoa beans were also on the list, although all John did with these was roast the 'nibs' and grind them with a pestle and mortar. The adulteration of chocolate came a few years later.

Being a devout and practising Quaker, John was heavily involved with the Society of Friends' chapter that met in Birmingham. In 1817, when he was 15, his aunt, Sarah Moon Cash, wrote to his elder brother Joel, who had already been in America for about a year:

> *John is grown into a fine youth, he possesses a fine open countenance, is vigorous in body and mind, desires to render himself useful in the business or in any other way; he possesses a strong athletic form with energetic powers of mind, he appears very amiable but his character is not yet formed; I sincerely hope his mind will be illuminated with Heavenly Wisdom, in which case he will be an ornament to Society; he is not of negative cast.*

In his youth, John had learnt to play the flute, but music was not highly regarded by the Society of Friends in those days, and so he gave it up. Instead he satisfied himself with two musical boxes, which he still possessed into his dotage.

From his late 20s, John was involved in various committees and organisations, starting with the Board of Commissioners for Birmingham from the age of 28. His father, Richard, became chairman of this organisation, and John himself became chairman of several of its sub-committees. One of these was the Steam Engine Sub-Committee, which concerned itself with smoke abatement. A few years later John

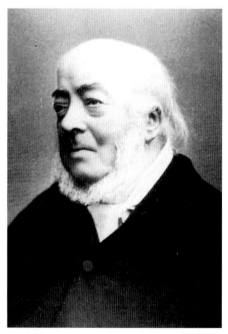

John Cadbury in 1885. (*Courtesy of Cadbury Archives and Mondelēz International*)

was appointed overseer of the poor in the city. The story goes that when he attended his first fine overseers' dinner, John was shocked to see the heavily laden table while starving people waited outside for financial assistance. He challenged the practice of expensive dinners, funded by the public purse, and it was immediately abandoned from that day forward.

In 1832, John was one of only six men to attend the funeral of an Asiatic cholera victim who died in Bilston, less than 10 miles away from Birmingham. The others were the four coffin-bearers, the vicar and Henry Street, a friend who had supported John in the matter of the overseers' dinners. A sketch by one Henry Newman shows the procession led by the vicar reading from his book and two of the coffin-bearers smoking pipes. The two men at the back are depicted in gentlemanly dress of the time, with John Cadbury wearing a frock coat.

Between 1829 and 1842, John went on three missionary visits to Ireland. By this time he had also been appointed clerk to the monthly meeting of Friends in Birmingham. He was interested in hospitals and was instrumental too in replacing chimney-sweep boys with mechanical devices. He also had an interest in savings banks. By 1842, the Cadbury family had already started to fund sickness and pension payments and later were instrumental in laying the foundations for the garden city movement.

John Cadbury's chief social interest was the temperance movement. It was as an alternative to alcohol that John initially offered his chocolate drink. He himself became a pledged total abstainer in 1832, when he was 31. He co-founded the Birmingham Auxiliary Temperance Society, and he had converted his father to total abstinence by the time of Richard Tapper Cadbury's death in 1860. When asked what should be done with all of the brewing barley, John started to take barley puddings to temperance meetings and hand them around for all to try.

It was said that John was such a devout Quaker that he didn't sit in an easy chair until he reached the age of 70. He retired from his chocolate business in April 1861 and handed it over to his sons Richard and George, who were 25 and 21 respectively at the time. Right into his 80s, John continued to take a

Cadbury's logo, c1866.

great interest in the firm, still visiting the factory in Bournville when he was a very old man. Sadly, though, on 11 May 1889, the founder of this great dynasty died and was buried in Witton Cemetery.

## Benjamin Head Cadbury (1798–1880)

Benjamin Cadbury was actually John's older brother, the eldest child of Richard Tapper Cadbury. He was born on 27 July 1798. Benjamin held similar interests to John, such as temperance and the abolition of slavery, and he was also active among the Birmingham Friends and especially interested in the prevention of cruelty to animals. But he doesn't feature as strongly in the business as other members of the family. However, he is mentioned here because he was one of the original Cadbury brothers.

In 1846, Benjamin Cadbury gave up the drapery business inherited from their father at 92 Bull Street, although his name does not appear in the Cadbury books at Crooked Lane. From 1847 to 1859 he is listed with his brother in paperwork relating to the Bridge Street property, and in 1847 the firm first became known as Cadbury Brothers. But Benjamin's name disappears again after 1860 – a time when the company was not doing so well. However, he was still involved with the business and could still be seen in the offices right into the late 1870s. It does appear, though, that he ceased to be a partner around the time the firm was floundering.

*Chapter 2*

# The Process and Manufacture of Chocolate and Drinking Cocoa

The Maya were an ancient race who lived in central America, where cocoa trees grow in the tropical rainforest. The native Mayans were the first to grow the trees and use cocoa beans. Primarily, they made a chocolate drink. But cocoa beans could also be used to barter with, instead of money. The beans were considered to be quite valuable. When the Maya travelled to Mexico to sell their cocoa, the knowledge was transferred to the Aztecs.

Like the Maya, the Aztecs enjoyed to drink chocolate in very large quantities. But they couldn't grow the trees themselves, as their climate was too dry. Cocoa trees survive in the rainforest because they thrive in humid conditions. They can grow in the shade and this means the canopy does not have to be cut down. Cocoa trees grow to a height of around 30 feet, whereas rainforest trees grow to a height of around 200 feet. The Aztecs took cocoa beans as a kind of taxation from the people they conquered, or they acquired the beans through trade.

Christopher Columbus was the first to bring cocoa beans to Europe in the late 1400s. Don Cortés also brought them back in the early 1500s. Cortés learnt that drinking chocolate was a favourite beverage of the Emperor Montezuma, and he found out how to make it, adding water, maize, vanilla and chilli. The Spanish learnt to replace the chilli with cinnamon, nutmeg and sugar.

For more than a century the Spanish kept this new, luxury drink a close-guarded secret. Cocoa beans were rare anyway. But by the 1650s, the chocolate drink had found its way to England, although it was still very expensive. In those days, it would have been made from chocolate blocks imported from Spain.

When John Cadbury opened his shop in Birmingham in 1824, he sold ground-up cocoa beans. The resulting drink, he believed, afforded 'a most nutritious beverage for breakfast'. Unfortunately, little evidence remains of his business or the production of chocolate from those very early days. However, a price-list does exist dating from 1842. Before this

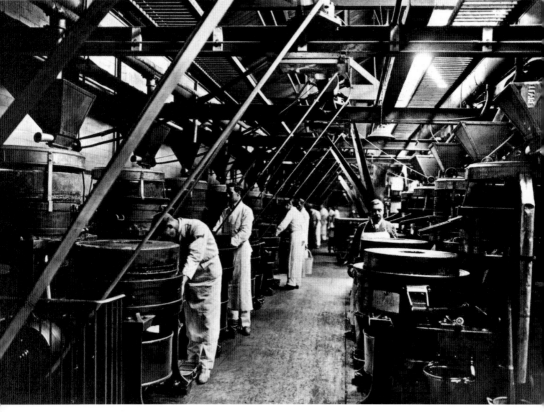

Early production. (*Courtesy of Cadbury Archives and Mondelēz International*)

there are only letters between Cadbury and his customers, such as this one, which was written on 23 June 1841:

> *RESPECTED FRIEND, – Thy favour of the 21 inst. came duly to hand with Bank Note value £10 – for which I am obliged and not less so for thy renewed order for Soluble Cocoa which will be sent off in a day or two – and the quality I am satisfied will continue to please.*
>
> *I enclose my list of Cocoa & Chocolates and shall feel particularly obliged for thy further orders, thou mayest depend on my best attention to them – and also in being supplied with a uniform quality. I am thy obliged friend, JOHN CADBURY*

The price-list lists fifteen different types of eating or drinking chocolate and ten different flavoured cocoas, and while some of the names seem

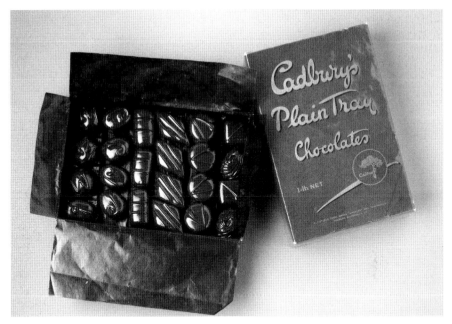

Plain Tray. (*Courtesy of Cadbury Archives and Mondelēz International*)

quite exotic – Broma, French Eating Chocolate, Fine Crown Chocolate, Rock Cocoa and Trinidad Cocoa, to name just a few – this was before chocolate manufacturers had discovered the method of pressing out excess cocoa butter and soluble cocoa. Cocoa butter is a fatty substance that occurs naturally in cocoa beans. Until learning how to press out the excess cocoa butter, manufacturers had to add starch to both absorb the cocoa butter and make the drink more palatable.

When John Cadbury's son George returned from Holland in 1866, the technology he brought home with him enabled production of a much milder drink, and Cocoa Essence was introduced. Eating chocolate may have been available before this, but it was this new technology that paved the way for chocolate as we know it today. Indeed, the first Cadbury's chocolate Easter egg was made in 1875.

From around 1889 onwards, experiments were conducted into the possibility of a milk chocolate. Then in 1902, development of what would be one of Cadbury's most popular products began. An earlier version had been produced c.1897, but the taste wasn't quite right and it took a few more years before the manufacturers were satisfied. It started with the installation of milk-condensing machinery, chocolate-grinding equipment, and a giant mixer that kept the chocolate warm

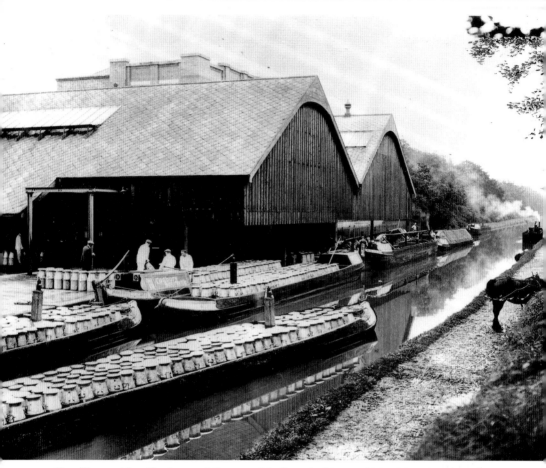

Canal boat with milk churns. (*Courtesy of Cadbury Archives and Mondelēz International*)

and moving until it was ready to be moulded into shape. Cadbury's Dairy Milk was finally launched in 1905. And in 1911, because milk chocolate was proving to be so popular, the firm's first subsidiary factory was built.

Although Cadbury Cocoa Essence was popular in the late 1870s and early 1880s, by the turn of the century the buying public wanted their drinking cocoa to taste richer and spicier. At first, the company resisted, firmly believing that their pioneering unadulterated Cocoa Essence was indeed the best. However, public opinion won out and, in 1906, Bournville Cocoa, the drink, hit the market. Yes, it had been treated, but not in the intense ways that the old product had been. Shortly afterwards, in 1908, the Bournville chocolate bar appeared.

In 1913, the Crunchie was launched as a rival to an Australian chocolate bar and in 1915, Milk Tray selection boxes started to appear. In 1920, Cadbury's Flake was developed, and in 1938 came the hugely popular Roses assortment.

The problem with milk chocolate is that it needs a lot of milk. The problem with milk is that if it is left too long or gets too warm, it goes off. It got to the point that as much as sixty percent of the milk ingredient was going sour in transit before the chocolate manufacturer could do anything with it. (Milk, until a large proportion of the water content is removed, is quite bulky, and therefore expensive to transport.) The Cadbury directors decided that the best solution was to build a condensing factory right in the middle of milk-producing country. Milk could then be collected, transported and delivered in a much shorter time-span.

The first Cadbury condensing factory was built on the Staffordshire and Shropshire border at a place called Knighton. This factory was connected to the factory at Bournville via canal. This was such a successful decision that in 1915, when demand for milk chocolate had grown even more and it had become the company's bestselling product, a second condensing factory was built, this time in Frampton-on-Severn in Gloucestershire. This village too was connected by water to Bournville and to Bristol.

Milk chocolate was made by mixing ground cocoa and sugar with condensed milk. Eventually, it was decided to take the ground dry mass of cocoa from Bournville to Knighton or Frampton to be mixed there with the sugar and the condensed milk. The unnecessary moisture that was left in the mix was then removed in huge ovens, and the new almost dry crumb mixture was returned to Bournville for the final process.

The milk also had to be completely clean. Empty milk churns were scalded in specially designed machines, all of the copper kettles had to be spotless, and the storage tanks, where milk could be kept cool for a few hours until it was required, had to be kept at a suitable low temperature.

By 1931 (the company's first official centenary), almost 600 farms provided Frampton-on-Severn with its milk, but they were spread out over a large area. So, two new concentrating stations were built: one at Newent, 20 miles away, the other at Charfield, 15 miles away. Here, two-thirds of the water content was removed from the milk, the residue being sent on to Frampton for the rest of the procedure. Knighton too

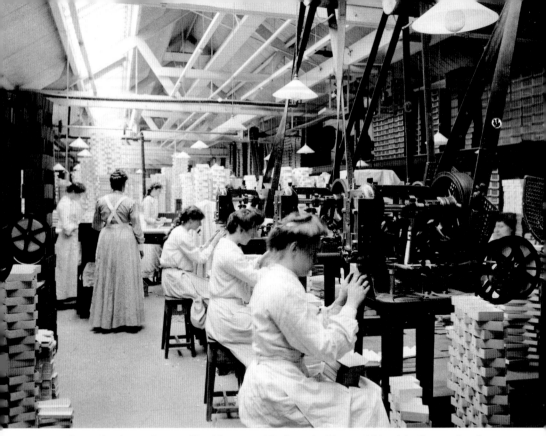

Early production at Bournville. (*Courtesy of Cadbury Archives and Mondelēz International*)

had a concentrating station at one time, but this had been closed by 1931.

Individual contracts were set-up between the farms and the company, and the animals, the premises and the people who worked there also had to be inspected for cleanliness and health.

The factory, its workforce and the product were all constantly growing, and interest in the business grew too. Outsiders were curious as to what was going on within these walls, and the workers were also interested to know what was going on around them. To satiate this curiosity, a visitors' department was created in 1902. For the workers, a new works magazine was started (see Chapter 14).

The visitors' department was to show the factory and Bournville village to guests. For years there had been occasional visitors to the factory, but they were usually personal friends of Richard and George Cadbury, important people connected to the manufacture of chocolate, or representatives of religious groups and philanthropists. A visitors' book was started in 1881. For the first twenty years or so the number of visitors was actually quite small, covering only around forty pages of

Chocolate box illustration. (© *Ian Wordsworth*)

the book. But from 1902 to 1908, the pages numbered closer to 130. Indeed in 1902, the first year of the visitors' department, almost 4,000 visitors were recorded.

Since those heady, early days, thousands and thousands of visitors have passed through the factory doors. Unfortunately, in the 1980s the practice was discouraged and later stopped thanks to the over-zealous Health & Safety Executive – perhaps with good reason in hindsight. Cadbury World development began in 1988, and the massive visitor centre opened its doors to the public for the first time in 1990.

*Chapter 3*

# The Early Years

## Bull Street (1824–1831)

The shop in Bull Street, next door to his father's drapery business, was John Cadbury's first business premises. At the time, trees and gardens could still be found right in the centre of Birmingham, and the shop had a garden at the back of it that included gooseberry bushes.

*Samuel Galton, the Quaker Gun-maker of "Dudson", was the first customer, giving a handsome order for 3 lb. of Souchong Tea at 8/-, and 6 lb. of Coffee at ¾ a lb., prices which would appal the present-day Tea and Coffee Drinker, but which were by no means unreasonable in those days, when both were heavily taxed luxuries.*

<div align="right">

Barrow's Stores Centenary 1824–1924
</div>

Cadbury's Cocoa Essence and Bournville Cocoa. (*Courtesy of Cadbury Archives and Mondelēz International*)

Somehow, 'Quaker' and 'Gun-maker' in the same sentence seem to be a little contradictory, considering the Friends were, in fact, pacifists.

Bull Street was one of the first shops in Birmingham to have plate-glass windows, and in the mornings John Cadbury could often be seen polishing them. His tea counter was also presided over by a statue of a Chinese man in native costume. Sadly this statue has recently disappeared, but the staff who currently work in the archive department at Cadbury's remember seeing him.

## Crooked Lane (1831–1847)

By 1831, John Cadbury's little business was doing so well that he was able to rent a warehouse in Crooked Lane, Birmingham. This winding road no longer exists. Both Crooked Lane and the shop in Bull Street were eventually overtaken by progress.

The old malt-house was on the right-hand side of Crooked Lane, coming from High Street. It adjoined the rear of premises in Bull Street (not the original shop but another property acquired by John Cadbury). The warehouse was a four-storey building with a sloping roof and two chimneys. There were vaults beneath the factory opening up into the pavement, with pulley and hoist for loading goods.

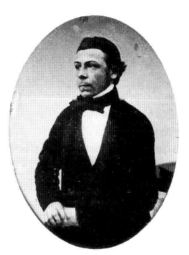

Richard Cadbury aged 24, 1859. (*Courtesy of Cadbury Archives and Mondelēz International*)

In 1847, the properties in Crooked Lane and Bull Street were both acquired by a railway company and were made into part of a tunnel leading to Snow Hill Station. The surface land was reconveyed to John Cadbury, and a new factory was built on it in 1856 for the printing company of White and Pike Limited. This building was also demolished when Martineau Street was built *c.*1880.

After a short time at premises in Cambridge Street, the Cadbury factory eventually moved to a new site, still in Birmingham.

## Bridge Street (1847–1879)

Two hundred people worked at the new factory in Bridge Street, Birmingham. Staff were not allowed to drink alcohol, nor could they smoke. They did, however, have half-holidays in the summer and were taken on excursions into the countryside.

A 20-horsepower steam engine was installed at the Bridge Street factory. This powered the grinding machines. There were also four ovens that could roast up to 2 tons of cocoa beans every day.

On 10 January 1849, the Birmingham Friends held the first annual gathering of their Reading Society at the Bridge Street property. This wasn't the only gathering of a non-business nature, and the factory was decorated for such meetings and events.

The Bridge Street factory remained in the names of both John and Benjamin Cadbury until 1859, when John's name appeared on its own

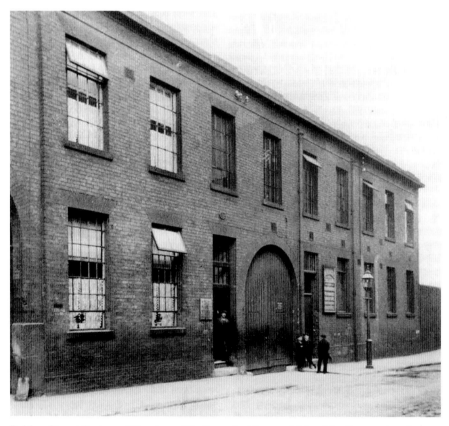

Bridge Street factory. (*Courtesy of Cadbury Archives and Mondelēz International*)

in the rate book for 1860. The factory was occupied and in use for thirty-two years, from 1847 until 1879, by which time it was considered seriously overcrowded. The building, which was of red brick and approximately 81 feet long at the front, was still standing in 1931 when a history of the business called *The Firm of Cadbury: 1831–1931* was written. By then a large car park had been added, lying across a filled-in branch of the Birmingham Canal.

## London

By 1854, the company had opened an office in London and by 1857 they also had a warehouse there. The Cadbury premises were located in Fenchurch Street and at Howford Buildings, but it appears the business moved around a little. A new address was added in 1860 – Swan Street off the Dover Road – but by 1862 the office and warehouses were both listed in Basinghall Street. Some years later, in 1871, the address had changed to Upper Thames Street.

## Royal charter – Queen Victoria

On 4 February 1854, John Cadbury and Benjamin Head Cadbury received their first royal charter:

> *John Cadbury and Benjamin Head Cadbury were admitted by Royal Warrant into the place of Manufacturers of Cocoa at Birmingham to Her Majesty. To have and enjoy all the Rights, Privileges, and Advantages to the said place belonging.*

## Decline

The years had been kind to the Cadbury brothers, John and Benjamin. But in 1855 this was to all change. Misfortune started with the death of John Cadbury's second wife, Candia, and was followed by a period of ill-health for the company founder. He suffered quite badly with rheumatic fever and his health never really recovered. As a result, he was now often away from work, and it wasn't just his health in decline by then.

By 1859, only eleven girls were working at the Bridge Street factory, and probably only around twenty or so workers altogether by the time

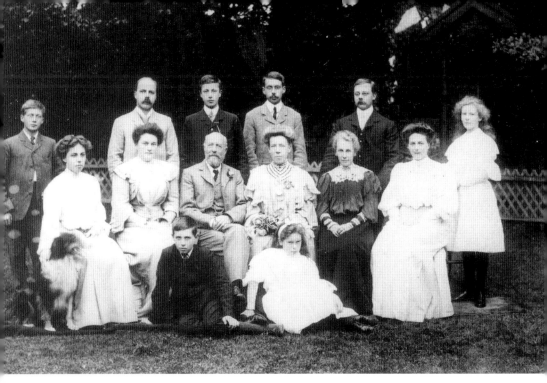

George & Elizabeth Cadbury and family. (*Courtesy of Cadbury Archives and Mondelēz International*)

the factory closed. When John Cadbury handed his business over to his sons, Richard and George, in 1861, it was thought that the company was on its last legs. The number of employees had dwindled and they were losing money fast. In January 1913, when he was reminiscing during a speech to a crowd that included previous employees, George said:

> It would have been far easier to start a new business than to pull up a decayed one which had a bad name. The prospect seemed a hopeless one, but we were young and full of energy. My brother and I each put £4,000 into the business, money left us by our mother. At the end of five years all of my brother's money had disappeared with the exception of £150. I had some £1,500 left, not having married.

Richard had married his first wife Elizabeth on 24 July 1861. George continued:

> I was preparing to go out as a tea-planter to the Himalayas, and he was intending to be a surveyor. I was living at home, but my total expenses for clothing, travelling, etc., were under ten shillings per week, and my brother was equally economical.

The firm's customers didn't exactly help matters, often dragging their own feet in paying bills. Richard Cadbury was known to go over the orders each morning and decide on how much, if any, of the order was to be supplied, depending on how much the customer still owed.

Not only had the company started to lose money as well as employees, but it was also apparently manufacturing an inferior product. In a speech made in 1921, George explained:

*Cocoa formed only a very small part of the trade – about one fourth. In those days they used only as much cocoa in a year as is now used at Bournville in an hour. They made a cocoa of which they were not very proud. Only one-fifth of it was cocoa, the rest being potato starch, sago, flour and treacle … [John and Benjamin Cadbury] were not content, however, to go on making such extremely common cocoa, and after six years they made cocoa for drinking, taking out the cocoa butter instead of adding flour to counteract it. They were the first firm in the kingdom to do so.*

Poster advertising Cadbury's, c1904. (*Courtesy of Cadbury Archives and Mondelēz International*)

*Chapter 4*

# Cadbury Brothers – the Next Generation

Richard and George Cadbury joined the business in the 1850s. In 1861, they inherited a floundering company from their father John Cadbury and probably, although no paperwork confirms this, their uncle Benjamin Head Cadbury.

From 1861 until Richard's death in 1899, and the subsequent conversion of the family firm to a private limited company, there is no doubt that a strong bond existed between the brothers and their workers. This probably started when they worked side-by-side with the workforce from 1850, when Richard joined the company, and 1856, when George followed. It still continued with George after his brother's death. Certainly in those early days, relations were very good indeed between owners and employees.

George & Elizabeth Cadbury, c1902. (*Courtesy of Cadbury Archives and Mondelēz International*)

## Richard Cadbury (1835–1899)

Unfortunately, there isn't very much available in print about the life of Richard Cadbury. This is a shame as the workers loved and respected him and he did so much for the product, for the business and for his employees.

Richard was born on 29 August 1835. He was John Cadbury's second son and he joined the company at Bridge Street in 1850. Richard spent a lot of his childhood away from home at boarding schools. He went

to a day school at first, but by the time he was 8 he'd been packed off to Charlbury. At the age of 11 he'd moved school again, this time to Hitchin. He was almost 15 when he left school and joined his father in the summer of 1850.

Richard enjoyed travel and was very creative, finding he was good at drawing and painting. He also used to write poetry and verse. It was Richard who compiled all the family's history documents into their Big Family Book. Like his father before him, who had that statue of a Chinaman overseeing sales of tea and coffee in the earlier stores, Richard had a very good eye for attractive detail. He went on to design many of the illustrations on the firm's packaging from the late 1860s onwards. He also very much enjoyed sport and exercise. He played football and liked to climb mountains whenever he had an opportunity.

To Richard it was the teaching and the practice of Christianity that was important, which meant he concentrated on mission work and temperance. As far as the company was concerned, he was a very good salesman and turned out to be quite adroit at credit control.

Richard married Elizabeth Adlington in July 1861, just before he and his brother were handed control of the company. In December 1868, following the birth of their youngest child, his wife died, leaving him with four small children. He was married again in 1871, this time to Emma Wilson, a widow with whom he shared religious and social beliefs and good works.

Richard was a kind and courteous man. When travel discomfort threatened during the winter at the Bournville factory – there being no shelter from the weather at the railway station – he would let the female workers wait in their heated dressing room until the train was signalled. Then he would blow a whistle so that the girls could run straight out to the train without hanging around in the rain and cold.

Richard Cadbury aged 29, 1864.
(*Courtesy of Cadbury Archives and Mondelēz International*)

Chocolate box lid. (© *Ian Wordsworth*)

During the 1880s, two of Richard's sons joined the firm: Barrow Cadbury in 1882 (although it's believed he may have spent an earlier summer at the company too, in 1879), and William Adlington Cadbury in 1887. Barrow travelled across the Atlantic for some of his work, but he also acted as personal assistant to both his father and his uncle. William was made responsible for the buildings, the machinery and the engines, and he stayed in that role until 1899.

Richard Cadbury became very interested in Egyptology and he made two visits to Egypt and into Palestine and the Holy Land. The first of these trips was in 1897. The second was two years later, this time with his wife and his four daughters, plus a son-in-law. It was while they were returning to Cairo from a trip on the River Nile that Richard started to complain of a sore throat. Two of his daughters also contracted what was then known as 'Nile Throat', but the doctor they consulted told them to continue with their journey. They arrived in Jerusalem on 18 March 1899. Within four days Richard was dead and the family later discovered that he had been suffering from diphtheria. He was brought back to England and buried in Lodge Hill Cemetery in Selly Oak.

In 1913, George Cadbury said of Richard:

*My brother was very good-natured, and constantly up to practical jokes and fun of various kinds.*

## George Cadbury (1839–1922)

George Cadbury was born on 19 September 1839. He was John's third son and he joined the company in around 1856. George didn't go away to school. Instead he was taught at home at first by a governess before moving to a Friends' school in Birmingham, where he was a day pupil. Shortly after his mother died, in 1855, he went to work away from home, for Rowntree's grocery business in York.

George, it seems, was more of a businessman than his older brother, and it is probably to him that the company truly owes its survival. George believed very much in hard work and self-denial. Once the business was back on its feet, he saw it as an opportunity to do good in the world, something that appealed to his strong religious beliefs. Like his brother, though, he did enjoy sport and exercise. He especially liked to swim and to ride.

For George, his religion came from within and was more of a personal enlightenment. This means he was interested in things like housing reform and pensions. He never partook of alcohol or tobacco. In the early days, when he and his brother took over the company from their father, he also abstained from tea and coffee, and even his morning paper, in order to plough every spare penny into the business.

It was George who, on learning of a new process to remove cocoa butter, went to Holland to see a machine:

*I went off … to Holland without knowing a word of Dutch, saw the manufacturer, with whom I had to talk entirely by signs and a dictionary, and bought the machine.*

This is the machine that helped Cadbury's to make a more palatable drinking chocolate.

In 1872, George married Mary Tylor from London and they had five children. Mary died in 1887, but in the following year George married Elizabeth Taylor, also of London.

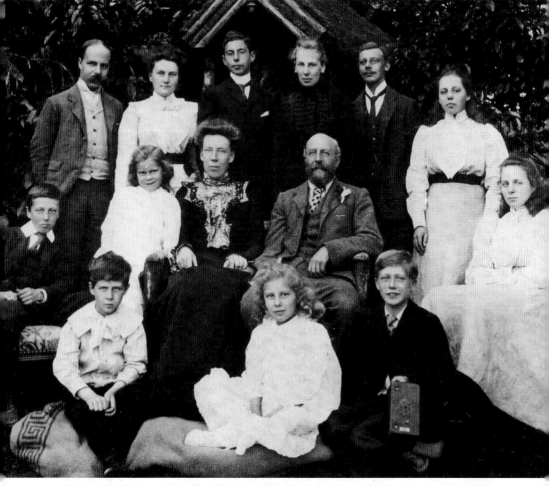

George Cadbury and family. (*Courtesy of Cadbury Archives and Mondelēz International*)

During the 1890s, two of George's sons by his first wife were to join the company: his eldest, Edward Cadbury, in 1893, who worked in foreign trade, and his second son, George Cadbury Junior, in 1897, who spent some months travelling in Europe before working on the chemical side of the business.

## The Bournville Carillon

The Bournville Carillon is a musical instrument commissioned by George Cadbury in 1906 as a gift to his workers following his visit to

Belgium. The famous Bruges Carillon dates from 1675 and he was very impressed with the sound of the instrument and the respect with which it was held by both local citizens and visitors. Henry Wadsworth Longfellow wrote his poem *The Belfry of Bruges* in 1842 following his visit there.

It is rare to find a carillon in the United Kingdom, there being only fourteen others, and this is one of only four in the country to have four octaves. It looks just like an organ, but is operated by pedals instead of keys, hit or punched by the hands balled into fists. It must have been quite painful! It consisted originally of twenty-two bells, all ordered from a foundry in Loughborough, Leicestershire. The carillon was housed in the belfry in the north-west tower of the new village school that had recently been built at Bournville.

These days the instrument consists of forty-eight bells across the four octaves, which means it's the largest one in Great Britain, although only one of the bells, the largest, is an original. The bells were replaced and added to over time by members of the family in memory of George

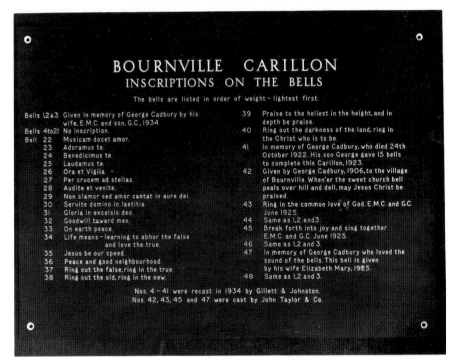

Inscriptions on the Bournville Carillon Bells. (*Courtesy of Cadbury Archives and Mondelēz International*)

Cadbury. Today the Carillon is housed in Bournville Junior School. Tickets for viewing by appointment are available from the Rest House. The Rest House was built by grateful employees to commemorate the silver wedding anniversary of George and Elizabeth Cadbury. It was opened amid much pomp and ceremony in 1914, but fell into disuse in a bid to save it from vandalism. The Carillon Visitor Centre was opened at the Rest House in November 1997 by Robin Cadbury. You can see it operating and playing tunes on YouTube.

George was still chairman of the company at the grand old age of 83 when he died on 24 October 1922. He had survived his older brother by more than twenty years and was the last connection to the factory at Bridge Street. To the very end of his life he was very much involved with the company.

## Chapter 5

# Back in the Black

When Richard and George Cadbury joined the firm in the 1850s, the Cadbury fortunes began to change, and this time for the better. What the brothers did in those ensuing years laid the foundations to what the company would become. Those first few years were very hard, and the company was well and truly losing money. However, by 1864 they seemed to turn a corner and recorded a profit – a small one, but a profit nonetheless.

Cadbury transport. (*Courtesy of Cadbury Archives and Mondelēz International*)

Several new lines were introduced to the company's repertoire, including Breakfast Cocoa in 1862 and Pearl Cocoa in 1863. These products were still being adulterated with the addition of starch to make the cocoa more palatable. However, at the end of 1866, probably after George Cadbury returned from Holland with his machine for removing the cocoa butter, a new beverage appeared in the list: Cocoa Essence.

In 1828, a Dutchman called C.J. van Houten invented a method to press the cocoa butter out of the cocoa, which made the product pleasant to drink without any starchy additions. The method was not known in England until 1866, when Cadbury's launched their Cocoa Essence. They were followed two years later by Messrs Fry in Bristol, but the Cadbury brothers were the first. It was upon this discovery that the future success of their business was built.

In 1861, when the firm was officially handed to them by their father, the company employed around twenty people. By 1879, this number had risen to about 230. The factory at Bridge Street was far too small for this number of employees, and inadequate for the growing needs of the business. Besides all of this, Bridge Street in Birmingham was developing at an alarming rate and Birmingham town centre was becoming a place less suitable for the manufacture of a food product. (Birmingham was not awarded city status until 1889.)

The firm did so well with its new products that it continued to expand until 1878 when a bigger factory was required. But the brothers were astute enough to realise that with the ever-burgeoning population of the town centre, even if they did move to a larger property, in a very short period they'd be obliged to move again. And so they turned their attention to the countryside surrounding Birmingham. While the company did not officially move into its new premises until 1879, 14½ acres of land was identified and bought in June 1878. This land was situated between the villages of Stirchley, Kings Norton and Selly Oak – villages for not much longer – approximately 4 miles from Birmingham, where a single cottage stood and was later demolished.

## The factory at Bournville

A small stream called the Bourn ran through this slightly sloping meadowland where trout swam, which is probably why the name 'Bournbrook' was considered. However, the cottage on the site had

been called Bournbrook, as well as a nearby hall, and they finally settled on 'Bournville'. It is believed this is because it was a French-sounding name and French chocolate was still very much in vogue. The site was bordered by a railway.

Building began on the new factory, as well as sixteen semi-detached cottages with gardens, for the foremen and other senior employees. The company also negotiated cheaper rail fares to Stirchley Street Station for those employees who still had to commute from Birmingham. These days the station is called Bournville.

Richard and George were almost constantly on the site, overseeing the building works. In fact, George took a cottage for himself at nearby Lifford. Another regular visitor was John Cadbury, the brothers' father, who was to see the factory enlarged again before his death in 1879.

The first brick was laid in January 1879, and by June the first machinery started to arrive. At the end of July, Bridge Street was closed, and in September the transfer was begun and completed. So enthusiastic was Richard Cadbury at this historic moment that he bought the railway tickets for a batch of girls arriving for their first day at the new factory, and he even accompanied them on their journey.

Easter Egg production. (*Courtesy of Cadbury Archives and Mondelēz International*)

Alongside the factory was a field, and there was a garden and a playground. The field was to encourage the men to play sports. The garden and the playground were apparently for the girls. There was a kitchen where they could warm up their dinners, but a cook was later engaged. Dining rooms followed.

The new factory was originally a one-storey rectangular affair, but it was improved and extended over the years. Because of the nature of chocolate manufacture, this new building had no windows on the south facade. Instead, this part of the factory was illuminated with skylights. Where there were windows, however, they were big and bright and provided wonderful vistas across the surrounding countryside.

The number of workers jumped up from around 230 to more than 300 shortly after they moved to Bournville. Within ten years this figure had increased to 1,200, and by the end of the century the number of employees was 2,685: 601 men, 1,885 women and 199 office staff and travellers.

Bournville Station, c1882. (*Courtesy of Cadbury Archives and Mondelēz International*)

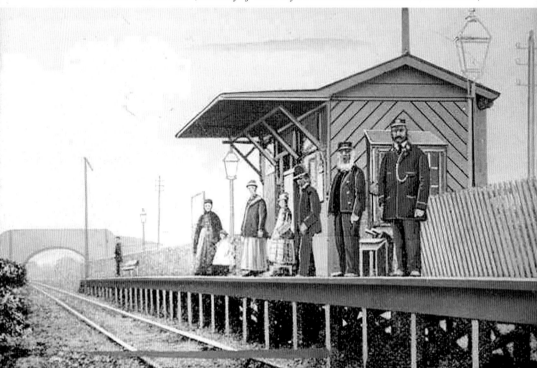

In 1895 the company purchased the land, previously belonging to Bournbrook Hall, that lay on three sides of the factory. This land was given over for outdoor activities, including the new girls' recreation ground. The hall itself was demolished just over a decade later. In 1896, an extra 12 acres was turned into a fully equipped sports ground and cricket pitch, for the men. It was such a good pitch that county cricket games were later played there. At around the same time, George acquired yet more land, on which his beloved 'Model Parish Mission' dream would later be realised (see page 76).

The factory and surrounding buildings continued to grow, both in size and in number. When the business was converted to a private limited company in 1899, the number of directors also grew – from two to five. This in turn led to the construction of a new building that housed the directors' offices. The new building first doubled and then tripled in size, with the land surrounding it expanding too until there was room to build an entire sports centre.

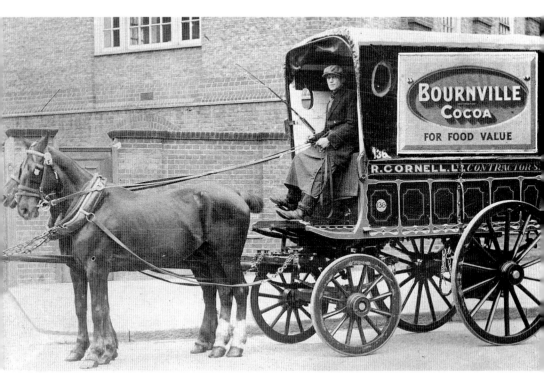

Bournville Cocoa horse and cart, c1915. (*Courtesy of Cadbury Archives and Mondelēz International*)

In January 1899, ten years after their father's death, forty-nine years after Richard joined the company and forty-three years after George joined, the brothers drew up a new agreement. They agreed that upon the death of one or the other of them the business would convert into a private limited company. Little did they know that this would become a reality less than two months later. Richard died of diphtheria in March 1899 and on 13 June that same year the private company of Cadbury Brothers Limited was incorporated, with George Cadbury, Richard's sons Barrow and William, and their cousins, George's sons, Edward and George Cadbury Jr as managing directors. The first board meeting was held on 5 July with George Cadbury Sr as chairman and Richard's eldest son Barrow Cadbury as secretary.

By the turn of the century, the firm had a workforce of almost 3,000.

*On February 28 1912, Cadbury Brothers ceased to be a private company and became a public one. Not quite three weeks later 200,000 6 per cent. preference shares of £1 each were allotted to the public. Special attempts had been made to advise customers of the firm, and members of the staff, of this issue, and by them far the greater part of the shares were subscribed.*

*The Firm of Cadbury: 1831–1931*

During the 1920s, the factory at Bournville was largely rebuilt with new machines brought in. Technology had advanced so quickly during and since the First World War that changes needed to be made, otherwise the premises were in danger of becoming old-fashioned and obsolete. Many of the buildings first built on the site had already been demolished to make way for new ones, but now these later buildings needed to be replaced with multi-storey blocks, specially designed to house the modern equipment. The rebuilding and modernisation programme was interrupted by the Second World War, but it resumed once again when the war was over.

# Chapter 6

# Advertising and Packaging

When the new Cocoa Essence was released at the end of 1866, there was a strenuous advertising campaign. Advertisements were taken out in medical journals, such as *The Lancet* and the *British Medical Journal,* as well as in trade journals, such as *The Grocer.* The advertisements were either blatant and obvious in their intent, or they were more subtle 'advertorial' – adverts disguised as news stories or features. In London, boards on the side of omnibuses were utilised and one Mrs John Clark made a point of physically visiting as many shops as she could asking for this new product from Cadbury's. (Mr John Clark was the company's representative in the London office.)

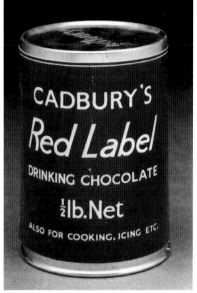

Cadburys Red Label. (*Courtesy of Cadbury Archives and Mondelēz International*)

Before Cocoa Essence emerged, however, the product had been pushed onto the unsuspecting public in other ways. One exhibit, specially designed by Richard Cadbury, had been sent to the International Exhibition in 1862. Later the same year a permanent position was taken at the Crystal Palace. The firm of Cadbury also paid an annual subscription to the Manchester Corn Exchange, to secure the right for them to have a stall there.

By the end of the late 1860s, the wrappings and boxes of Cadbury products started to change. There was no wide use of colour printing at the time, until Richard Cadbury put his artistic talents to good use. It was about then that he started to make pictorial designs that could be used on the lids of chocolate boxes, and had them printed

in sheets. The first such label was painted in 1868. It depicted a little girl in a muslin frock with a kitten on her lap and a red flower in her hair. It was first used on boxes of chocolate crèmes at the start of 1869 and was a sign of things to come. It is said that Richard used his own children as models for these early paintings, and the scenic views were inspired by his holidays in Switzerland. Very soon pictures of children were adorning many of the company's products, followed by flowers and then scenery. Four fruits were used to illustrate a series of products – strawberry, cherry, orange and raspberry. Later, there were ladies wearing fine apparel decorating the products.

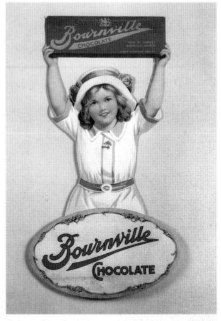

An early advertisement for Bournville Chocolate, c1908. (*Courtesy of Cadbury Archives and Mondelēz International*)

The company had a shop in Paris, at 90 Faubourg St Honoré, mainly because France was believed to be the home of good chocolate and the address gave them some standing. This belief that French chocolate was somehow of a superior luxury quality also influenced the naming of the new village the family built at the start of the twentieth century – Bournville.

For many years, advertising was handled by an outside agency, Messrs T.B. Browne Ltd of London, although it was managed in-house by E.S. Thackray. In 1905, however, the board decided to bring advertising under the company's direct control. The new department was put under the direction of George Cadbury Sr, but this is where the 'introducers' operated. These were similar to the commercial travellers, but instead of selling to customers, they assisted with shop displays and they fixed Cadbury lettering onto shop windows.

During both world wars, advertising at the company was decentralised. This was very much an experiment as it was believed that local markets required different treatments. All advertising had previously been managed by the central department in Bournville. However, local advertising committees were then formed using the new depots that

Cadbury's Finer Chocolates. (*Courtesy of Cadbury Archives and Mondelēz International*)

were built in the 1920s as their local headquarters. They were also allocated an advertising van to help.

A marketing group was also created during the 1920s as the study of marketing was a new science in those days. The object of this department was to forecast and meet the demands of the public. Barbara worked at the company from 1945 to 1950:

> *I remember (I think it was Adrian) talking to our team about the new packaging for Roses; he was interested in what we thought about changing the boxes to the round tins.*
>
> *Bournville: The Workers' Story*

Jean was born in the village of Bournville and her father worked at the factory. It seemed only natural, then, that she should follow in his footsteps. She joined the company in 1958, starting in the typing pool. She progressed to becoming one of the cocoa buyers' secretaries before moving on again:

Cadbury's logo, c1961–2003.

*Following this, I worked for Gordon A. Wells ... who was in charge of the display men. These men travelled round the country displaying the Firm's goods for sale in the retail outlets.*

*Bournville: The Workers' Story*

Perhaps one of the most memorable and controversial characters in Cadbury advertising, the Flake girl, appeared in 1959, and remained on our screens for more than fifty years. In 1968, it was the turn of the original man in black, the Milk Tray man.

In 1969, Cadbury's merged with the firm of Schweppes.

*Schweppes was one of the first businesses to recognise the power of advertising and progressively the power of the press, radio, TV and now international satellite TV.*

*Tea & Foods News, May 1983*

In April 1983, a book on the history of Schweppes was published by retired company secretary Douglas Simmons. *Schweppes: The First 200 Years* included a whole chapter on the history of advertising the product. Simmons had been with the company for forty-six years when he retired in 1978.

During the 1970s in particular, many of the Cadbury brands saw a huge increase in sales and popularity. These included Flake, Fruit & Nut, Whole Nut and Cadbury's Dairy Milk. This is probably due to the intense and memorable television advertising campaigns. In fact, there was also a surge of new products from the 1970s to the mid-1980s:

Cadbury's Caramel, c2018. (*© DennisMArt/shutterstock.com*)

- Curly Wurly first appeared in 1970, disappeared then made a comeback
- Old Jamaica also showed up in 1970, but is no longer made
- Cadbury's Creme Eggs arrived in 1972, and the recipe has been changed several times since then
- Wispa was trialled in the north-east in 1983 before going nation-wide
- Boost Coconut arrived in 1985, but was gone again by 1994
- Twirl was originally launched as one finger in Ireland in 1985, but by the time it hit the UK, it had grown another finger

In 1998, some of the Cadbury old favourites had a bit of a facelift and were given a new lease of life. Operation Purple Nation hoped to relaunch three top brands, taking up several pages in the last ever edition of *Cadbury News* (see Chapter 14):

> *OPERATION Purple Nation. It's code for the biggest ever push behind Cadbury's flagship CDM Megabrand – Cadbury's Dairy Milk, Fruit & Nut and Whole Nut.*
>
> *"The aim is to get people to take a fresh look at Cadbury's Dairy Milk and to remind them it's the very best they can get," said senior product manager Sarah Rowberry, who is co-ordinating Operation Purple Nation.*
>
> *"It is fantastically exciting. This is another key milestone in the brand's rich history which spans 93 years."*

*Operation Purple Nation is not just new advertising or a promotion. It is a concerted campaign which pulls together all the strands of Cadbury's marketing strategy – communication (advertising), design, product, range, promotion and display.*

Moving on from the old 'glass and a half of fresh cream milk' catchphrase, the new communication slogan from this point on would be 'chocolate and a half'. Design-wise, the chocolate chunk image with a glass and a half of milk being poured into it, adopted the year before, was retained and stylised. The product didn't need to be changed. 'We have always known it is the best-tasting chocolate in the marketplace,' added Sarah.

Promotions at the time included half as much chocolate in a bar for the same price – the total opposite of what's been rumoured more recently about chocolate bars being made smaller for the same price rather than imposing a price hike on consumers. Finally, the relaunch was accompanied by a new range of display equipment.

# Chapter 7

# Travellers

Dixon Hadaway was the firm's first commercial traveller. He was from the north of the country and worked for Cadbury's from 1850 to 1890. His 'patch' was from Rugby in the Midlands to the north of Scotland, but it excluded Manchester and Liverpool. In 1862, the company representative in Manchester was Samuel Gordon, closely followed by Richard Baldwin in 1863 – according to the Corn Exchange records – although Gordon's headquarters were in Liverpool. Hadaway was such a regular caller that it was said his customers could set their clock by him.

Stack of cocoa in yard. (*Courtesy of Cadbury Archives and Mondelēz International*)

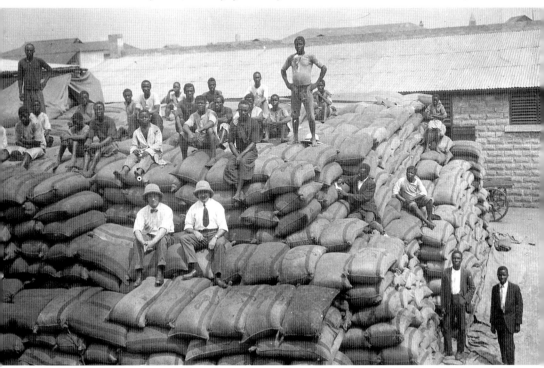

One of the firm's travellers, who joined the company in 1869, was George and Richard's younger brother Henry, John Cadbury's youngest son who was born in 1845. Sadly, he died of typhoid fever in 1875. Henry was very much loved by the workers at Bridge Street who said they felt they'd lost a brother too when he died. He left a widow and a baby daughter.

The Cadbury brothers had a customer in Dublin as early as 1842. But it was during the 1870s that the company's overseas interests first started to emerge. The first traveller to leave the country on company business was Simeon Hall. He travelled to Ireland in January 1873. Throughout the 1870s, Cadbury's continued to have a presence in places such as Valparaiso in Chile, where the product labels were printed in Spanish, Montreal in Canada, and in Paris where they also had a shop. The shop was under the management of an employee who had worked in the plain chocolate moulding department at Bridge Street.

As the company gradually learnt how to improve the cocoa without adulterating it, they systematically phased out those lines that still had unfavourable additives. During the 1870s, all of these cocoa products were eventually discarded and replaced with the 'purer' lines. One product, however, remained, and it was very popular, earning the travellers a decent sum. They called it Chocolate Powder, so strictly speaking didn't sell it as cocoa but it was mixed with starch and, in June 1891, Richard and George pulled it from their product list. However, because it was still selling so well at the time, the commercial travellers were generously compensated for this particular loss of income.

Edward Cadbury, George Cadbury's eldest son by his first wife, joined the company in 1893, and the company's foreign trade started to grow. Before that, in 1882, Richard Cadbury's eldest son Barrow Cadbury joined one William Tallis on a visit to the United States and Canada. This resulted in the establishment of both the American and the Canadian agencies, which in turn resulted in Cadbury's cocoa and chocolates appearing in shops in New York, Brooklyn, Philadelphia and in Canada.

*The Bournville Works Magazine* carried a contribution by Edward J. Organ in its September 1903 edition (see also Chapter 14). His *Notes of a Traveller* ran for almost three pages. It's rather flowery and long-winded, but very typical of the kind of writing that was published in those days. However, it does have a relaxed feel to it, as the start of the second paragraph demonstrates:

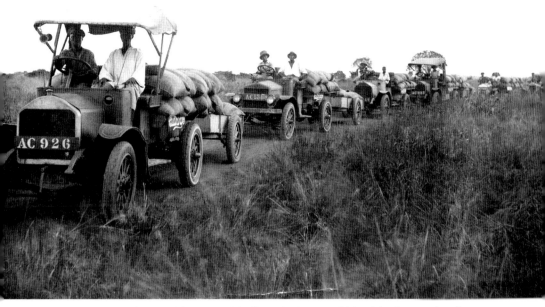

Transporting Cocoa. (*Courtesy of Cadbury Archives and Mondelēz International*)

*I had passed a few days in the Macedonian capital—Salonika—and was eager to get to Constantinople. Being pressed for time, I took the first boat that offered—a dirty little Greek coasting steamer, flying the Turkish flag. As I rowed on board on a broiling afternoon in August, in company with two chance acquaintances—a Levantine of nebulous origin, and a Frenchman, companion of a former voyage, who had both decided to make the journey with me—I was filled with some misgivings as to the fate in store for us during the next two or three days, for Greek boats are notoriously ill-managed and uncomfortable.*

How charming. It reads more like the opening of a mystery novel than an article by a commercial traveller. Don't worry, they all made it quite safely in the end.

Even though there was a shop in Paris and commercial travellers and board members travelled overseas on business or research trips as early as 1873 (to Ireland), the export side of Cadbury's probably started in 1881 when Thomas Elford Edwards went to Australia. The first orders from him there were received at Bournville in the summer of that year. From Melbourne he looked after the company's interests in both Australia and New Zealand. However, when this area became too large for just one representative, he suggested a colleague who had

joined the firm at Bridge Street, just before they moved to Bournville. William Cooper had been on the same committee as Thomas Edwards and together with others they undertook religious and social work in and around the new premises.

In August 1882, William Cooper joined Thomas Edwards in Melbourne, before moving to Sydney. From thence, Edwards managed the interests for Victoria, southern Australia, western Australia, Tasmania and New Zealand, while Cooper looked after New South Wales and Queensland. In 1887, William Cooper was joined in the Sydney office by his brother, T.E. Cooper. In 1890, one of Edwards' staff from Melbourne, F. Meadowcroft, was sent to New Zealand on a permanent basis, where he operated out of Wellington. During the same year, Thomas Coley took over southern and western Australia and worked out of Adelaide.

Edward Cadbury, who was by now the director for exports, visited the Australian operations in 1901, William Cooper paid a visit to England in 1902, and Thomas Edwards retired shortly afterwards, in 1903.

Southampton Depot. (*Courtesy of Cadbury Archives and Mondelēz International*)

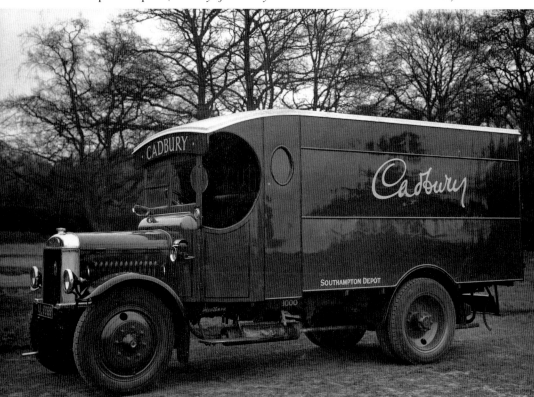

William Cooper was then given the whole of Australia to manage, with his brother as his Number Two. Now they had their main headquarters in Sydney, but they retained branches in Melbourne, Adelaide and Brisbane.

The property in Australia was rented during the 1880s and 1890s. The office at 423 Kent Street in Sydney consisted of:

> *… a single floor for a small but new building at 25s a week. That building … served our purpose – with the addition of the basement at a later date – for some years, when we removed to more convenient and more presentable quarters at 333 in the same street. It is interesting to compare Kent Street as it then was with the Kent Street of big warehouses of the present day. It was what would now be looked upon as a slummy area, houses or hovels perched higgledy-piggledy on the rocks on both sides of the street or nested round a kind of courtyard where level spaces permitted. There were hoardings at intervals and goats wandering about at will chewing off the posters as high as they could reach.*

William Cooper, *The Firm of Cadbury: 1831–1931*

In 1898 the firm bought the first overseas depot outright, in Sydney, at 267 George Street in the main commercial part of the town. This building was bigger than required at first, but the firm grew into it over the years as the business grew. It lasted until 1926, when the company built a new warehouse and office in Sydney.

From Australia and New Zealand, the firm concentrated its efforts on South Africa. Harry Gear had travelled there in 1886, but seven years later a permanent representative was installed, R.B. Brown. He had worked in Scotland before this, as a letter-fixer, a role that was similar to that of the introducers who worked all over the country. George Fiskin was sent out to assist him in 1897, and he stayed until his retirement in 1929. R.B. Brown remained incumbent in this role until shortly after the Boer War. He became an import agent for Cadbury's until his retirement in 1927.

After South Africa, the next port of call was India. The first traveller to visit that country was William Cooper, on his way from Australia on a visit home in early 1888. He spent some time there, several months in fact. In 1891, William went on another trip, this time taking in China and Japan, amongst other places, and making a return trip to India before arriving back in England in May 1892.

William Cooper was sent back to Australia, and J.E. Davies was appointed the firm's representative in India, where he stayed until his retirement in 1925. During that time he made thirty-five visits to the East.

In 1897 and 1898, export traveller H.E. Waite spent fifteen months visiting the West Indies and South America. Later that year he went to Constantinople, Smyrna, Egypt and Malta. Then in 1899 he travelled to the East. When he retired in 1905, his area was split into three: China and the Far East; South America; and the West Indies and Canada. In 1897, Scottish traveller Frederick Port made his first visit to Iceland and a year later the Export Office at Bournville used a typewriter for the first time. Both were quite groundbreaking incidents.

Still in 1897 – it must have been a very busy year for Cadbury's – William Adlington Cadbury visited Trinidad in the British West Indies. William bought two neighbouring estates, 300 acres at La Merced and 127 acres in the Maracas Valley, where cocoa was grown. The land wasn't purchased to ensure the supply of cocoa beans. It was bought for information, education and research on the cultivation of the product, and to improve and ensure quality. The amount of cocoa produced by these estates was only a fraction of that needed by the Bournville factory and the estates were too small to justify high overhead costs. So in 1930, a third estate was acquired, 320 acres in La Montserrat.

After the end of the First World War, trade restrictions still meant English manufacturers were unable to export cocoa and chocolate. Those countries Cadbury's exported to were now making their own products and competition was hotting up as well as export duties increasing. But in the spring of 1930, Australia placed a total ban on a number of imports, including chocolate and confectionery. Fortunately, the company must have had some foresight that this would happen as, in 1919, Cadbury started to look at manufacturing its products abroad. Following a merger with Fry's, which also happened in 1919 (see Chapter 18), Cadbury acquired an interest in Fry's Canada in 1929. The Fry's factory in Montreal wasn't a purpose-built factory, like the one at Bournville, but had been adapted from its previous use, by Fry's, to make chocolate.

In January 1920, a small group of representatives from Cadbury's met in Sydney with a view to finding a suitable location to build a factory, as a manufacturing plant for both Cadbury's and Fry's, plus a third company, Messrs James Pascall and Sons Ltd. It was decided that Sydney wasn't at all suitable as it was both too warm and too humid for

the successful production of chocolate. Melbourne was also considered and discounted. But in March 1920, the group discovered a place near Hobart, in Tasmania. Once they'd weighed up the pros and cons, the group was instructed to build the factory there.

Not only was the climate cool in Tasmania, but the site chosen on the Claremont peninsula was beautiful, and that fitted in nicely with the Bournville ideals. Tasmania was also free at the time of any labour disputes. Although goods would still have to be

Cadbury's merchandise ("merch").
(© *Ian Wordsworth*)

shipped to the mainland, the new site enjoyed good communication by water, road and rail. Electricity was cheap too. But it was necessary to construct roads, railway lines and electricity cables as well as 3 miles of gas mains.

Building proper didn't start until March 1921, but within two years the factory was virtually complete. Six separate blocks were built and there was a number of subsidiary- or out-buildings. A garden village, just like the one in Bournville, was also started. The firm built twenty-two houses, a school and a small Friends' Meeting House, and these were followed a short time later with a recreation ground and golfing facilities on some neighbouring land. The houses were built for the skilled workers shipped over from England. Most of the remaining employees commuted daily by train from Hobart.

It was a hard slog in Australia, though, as there had been numerous shipping and duty difficulties since the end of the war. After the amalgamation of Cadbury and Fry in 1919, the firm decided to form a combined selling agency in New Zealand for the products of both companies. This new company was called Cadbury's and Fry's (New Zealand) Ltd, and it was incorporated in October 1920 as a private company. The headquarters were in Wellington and the new managing

director, F. Meadowcroft, had been the Cadbury representative in New Zealand for the previous thirty years. He also managed an established team of commercial travellers.

Once again, import duty in New Zealand was increased, and it became quite difficult to compete with the local manufacturers. So when the firm was approached by a local biscuit and chocolate manufacturer, Messrs R. Hudson and Co of Dunedin, offering another merger, an agreement was made and signed on 28 February 1930. This company was called Cadbury-Fry-Hudson Ltd and it went on to replace the company of Cadbury's and Fry's (New Zealand) Ltd in this part of the world.

Meanwhile, across the Atlantic, a new Canadian firm was registered as Cadbury Ltd in 1929, in Montreal. The first product to be made there was Cadbury's Dairy Milk, in 1930.

This local manufacture of chocolate in other countries did not mean that all exports from Bournville to those countries ceased, except where there was an actual total prohibition on imports. Not all products in

Selection of chocolate boxes. (© *Ian Wordsworth*)

the firm's line were made abroad. Many, particularly the expensive ones, were still made in Bournville.

None of the species of cocoa tree was native to Africa. The plant was first introduced to the Gold Coast in 1879, from a few pods brought in from the island of Fernando Po. The tree didn't come from there either. It is native to South America. By 1881, the Gold Coast was exporting cocoa beans, granted only about 80lb in the first year, but within forty years the total exported weight had increased to 233,000 tons a year, or forty-three percent of the world's total output. As the government there encouraged the indigenous Africans to develop their own land for themselves, all the cocoa cultivation was done by independent local growers. White settlers, in fact, were forbidden from acquiring land. This meant that by 1929, the greatest cocoa output in the world was produced by native farmers, working on their own land and on their own account.

In 1908, Cadbury's turned its attention to this Gold Coast production, and W. Leslie, who was a government agricultural inspector in Trinidad, was engaged by the company to go out to West Africa. He spent the next two years preparing the way for the firm's expansion into that country at a time when the native farmers there were being encouraged to improve the standard of their product. Improvement was necessary: when the cocoa arrived in London, it was dirty and fermented. A second representative, G.G. Brown, who also came in from Trinidad, was engaged to make further investigations on the firm's behalf. However, he left Cadbury's in July 1909, and Harry Craig, an introducer, was sent out to assist Leslie.

William Cadbury went out to the Gold Coast in 1909, where he witnessed for himself the difficulties involved in buying cocoa there. Shortly afterwards, the firm purchased 14 acres of land. The governor, Sir John Rodger, agreed to this because he thought it would help to educate the local farmers. There were plans to build a railway close to this site, hence the purchase, and a small house was bought there too. But when the plans – and the route – changed for the railway, the estate proved to be of no use at all and it was sold back to the original owner.

*Chapter 8*

# Education and Training

Cadbury's was an incredibly enlightened company. Its managers knew that in order to reap good business, they had to look after their assets – namely, their workers. They also believed in the safety and wellbeing of said workers, knowing that happy and healthy employees also result in a better return. And they took the view that a work-life balance should be instilled into the young workers too, for the young workers of today are the experienced workers of tomorrow.

> *As employers, we only have a right to use the labour of young people if we make sufficient provision for their proper development … The privilege of using the cheaper labour of these young people should only be allowed by the community on the understanding that we do not harm their growth as intelligent citizens. Hence, the education given should be of some cultural value.*
>
> From an address by George Cadbury Jr, 1926

As early as 1852, Cadbury's factory girls were allowed to leave work an hour early twice a week in order to attend evening classes. And for many years, the Cadbury family were associated with adult learning – they were connected to what was known as the Adult School Movement.

In 1906, an educational system was adopted that related to work in the factory. If a boy or girl was employed by the factory at the age of 14 to 16, it was made a condition of employment that he or she should also attend evening classes twice a week. The age limit was raised to 17 in 1909 and to 18 in 1910. Apprentices and male clerks were required to continue classes until the age of 21 and 19 respectively. Some of the classes even took place during the day, in factory time, such as PE – known then as PT, physical training – maths, technical studies (for the men) and housewifery (for the women). The majority took place in the evening, though, at institutes across the district.

In 1913, the junior workers started to attend a half-day class each week, in addition to one evening a week. The evening class later

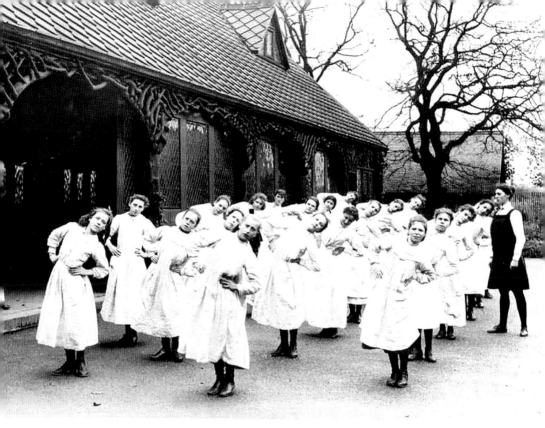

Girls' Swedish drill class, c1902. (*Courtesy of Cadbury Archives and Mondelēz International*)

became optional. In 1917, another change came with the youngsters being offered the chance of another half-day class, but this time without pay. Those who distinguished themselves in the voluntary class were rewarded with small bursaries or prizes. Surprisingly, a third of eligible workers took advantage of this additional time, and two half-days a week meant the range of subjects learnt could be increased.

By 1930, all young men employed at the firm were required to attend two half-days of education per week until they reached the age of 18. This was also compulsory for all apprentices to the age of 21, and all male clerks to the age of 19. Females over the age of 18 were entitled to one half-day per week, sometimes more, but this was optional. In any case, anyone who attended classes, whether compulsory or voluntary, received pay.

Stirchley Institute, which was very close to the factory at Bournville, was one of the first such learning centres. It was built by Richard and George Cadbury in 1892 for the purpose of adult learning, as well as for recreation, and for the use of the villagers of Stirchley. While it was

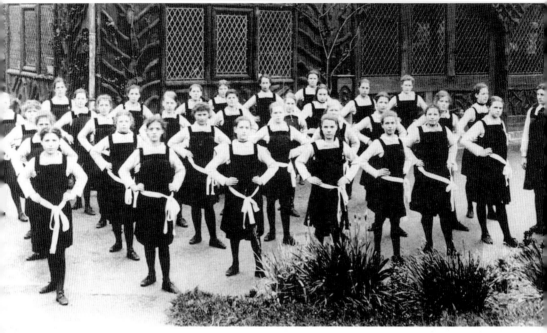

Girls' PT, c1903. (*Courtesy of Cadbury Archives and Mondelēz International*)

initially designed with the youth of Bournville in mind, other youngsters who didn't work for the firm were also admitted. The 'continuation classes' soon grew too large for this institute, however, and first the boys' school and then the girls' school were moved to other buildings in the area. None of these buildings proved suitable, though, as they weren't designed specifically for schooling and education. So, following discussions with the Birmingham Education Authority, Richard and George Cadbury erected another purpose-built school on land given by the Bournville Village Trust.

It was agreed that the Birmingham Education Authority would staff the boys' and girls' continuation schools and run them during the day, but the firm should have full use of the buildings at other times and they remained the property of the company. Desks and chairs were provided by the firm, but the education authority provided the consumables, such as ink and paper. The school buildings were completed in 1925.

The schools were one-storey and the buildings surrounded three sides of a quadrangle of grass. The classrooms opened out onto a veranda that also surrounded the quad on three sides, so that the doors

could be flung open in fair weather and classes even moved outdoors. There were two assembly halls and twenty-four classrooms, fourteen of which were in the girls' department where subjects such as cookery, sewing, music and biology were taught. The remaining ten classrooms were in the boys' department. These were adapted for the teaching of drawing and included a science lab and a workshop. Both the boys' and girls' sections had a library.

One of the assembly halls was fitted out with gymnasium equipment and much of the time at school was given over to physical training. Gymnastics and swimming were compulsory for boys and girls, and this was done in conjunction with the works doctor. All of the PE/PT instructors were employed by Cadbury Brothers Ltd. Other classes consisted of English, history, geography, maths and science, although art was taught in the Bournville School of Art in Ruskin Hall, which overlooked the village green.

Swimming was compulsory for boys and girls. (*Courtesy of Cadbury Archives and Mondelēz International*)

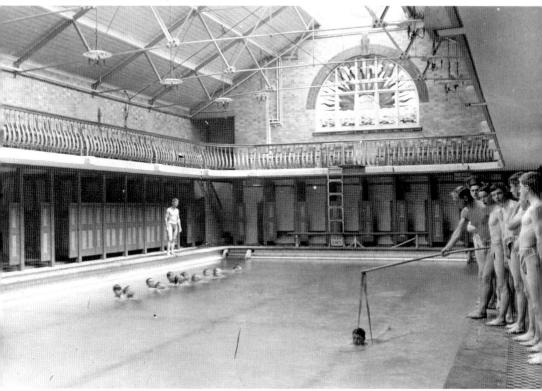

For older students, more technical subjects were taught, including machine drawing, French, book-keeping, mechanics, chemistry, etc. For the females, there were also the options of mothercraft and home nursing. These subjects were not necessarily certificated. The object was to offer the workers the opportunity to better develop their intellects. However, some students did pass from the continuation classes on to university. A number even went to Oxford or Cambridge. Aside from these daytime continuation classes, there were also still the evening classes.

From 1920, the regular schools finished three times a year and at the end of each term a new influx of young workers would arrive at the factory. This resulted in what were called Initiation Schools. They lasted for around a week and took place three times a year to coincide with this mass incursion. The sessions introduced the youngsters to life in the factory and included films, visits to the various departments, and a works tour.

When the term-time continuation classes were closed, the firm even launched vacation schools. Today these would be known as summer camps (see Chapter 9).

## Apprenticeships and vocational training

Many of these classes covered the general education of the young workers at Cadbury's. However, the firm also provided training so that they could learn how to do their jobs properly and better or even advance themselves. There was a limited number of active or live apprenticeships at a given time, despite there being a large number of different trades to learn.

When an apprenticeship became available, applications were invited from boys still at school due to leave soon, but also from boys already working within the company who were attending continuation classes. The applicants were set an exam, and departmental and/or school reports were requested. Those who scored the best mark in the exams were invited for interview in front of a panel. Once appointed, the apprentice would be tested, via another written exam and an oral test, every year. Strengths and weaknesses would be identified and hopefully built upon or addressed.

There was also a system of vocational training throughout the factory and in the offices, but this was aimed more at the actual methods

Chocolate box illustration. (© *Ian Wordsworth*)

used in the factory rather than generic skills like book-keeping. For example, class instruction was offered in cardboard box-making from 1911. One evening class was dedicated to shorthand.

Promotion within the firm was also decided on via a process of application. Anyone interested in being promoted to a more senior position had to apply for the role and be interviewed. They had to sit an exam too. In 1919, however, a new process was trialled whereby a short

Chocolate box illustration. (© *Ian Wordsworth*)

training course was provided. It was so successful that the procedure continued and many workers were promoted as a result of attending the course.

If any man or woman wished to improve his or her own performance, they could also attend an evening class in 'industrial administration' twice a week in the winter months for two years. The topics included

were rather like any business administration course today: industrial (now employment) law, general factory management (or office management now), costing, bought ledger and sales ledger (business finance), and so on. Another course was for the girls and was in office organisation. This one ran for one morning or one afternoon per week for thirty to forty weeks. For this the participants were selected, and the topics were the same as for the industrial administration course. Attendance on these courses did not guarantee promotion but would stand in an employee's favour if they did wish to apply to move up the ladder.

## Chapter 9

# Sport and Recreation

Richard and George Cadbury were both very keen sportsmen. Richard played football and liked to climb mountains, and George enjoyed swimming and riding. The pair of them also played cricket and hockey and went skating and sailing. As both young men also spent a lot of their time at work, it was probably a natural progression, then, for them to start a works' cricket team, a team in which they both played and were successful.

After the brothers inherited control of the business from their father, they also encouraged the male workers to play football. On slack days, the boys were often sent off early to play a game. In the winter, a half-day holiday would be given so that they could go ice skating. George

Women's football team. (*Courtesy of Cadbury Archives and Mondelēz International*)

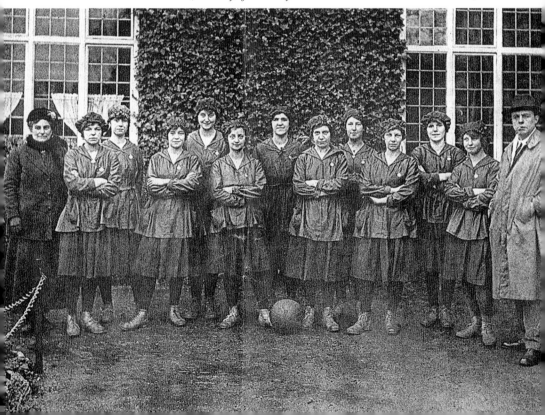

purchased a bicycle so that the boys could learn to ride during their dinner break (midday break in Birmingham). Once they'd successfully learnt to ride the old 'bone-shaker', they were permitted to take it home with them.

When the new factory opened in Bournville in 1879, the workers were surprised to see a field right next to it. This was for the men to play cricket and football. Later, a works band was added to the activities. And, apart from all the rooms in the factory used for the different stages of manufacture and packaging of chocolate, there was also a reading room. Later, there would be a library and several recreation rooms set aside for pensioners.

In the 1880s, a casual ramble by a handful of friends from the works turned into a regular spring outing for the clerks into the Lickey Hills. To this were added cross-country races, golf tournaments, singing, speeches and that good old British stalwart: tea.

## Athletics

In 1896 the men's and girls' recreation grounds were opened next door to the Bournville works. The men's ground was given a pavilion in 1902, which included its own shower and bathing facilities and a fully equipped gym. This was done in honour of King Edward VII's coronation. There was also an open-air swimming pool for the men.

Football was encouraged. (*Courtesy of Cadbury Archives and Mondelēz International*)

The playing fields consisted of one football ground, two hockey grounds, two cricket pitches, three lawn tennis courts, two hard tennis courts and two bowling greens. The hard tennis courts were on the other side of the stream (the Bourn) and were illuminated at night with electric lighting so that games could be played after dark during the winter.

The girls' ground also had a gym and several pitches, for cricket, hockey and netball, plus seven lawn tennis courts. It was less formally laid out for athletics than the men's ground, though. The girls could also enjoy themselves in gardens and on lawns, where they could dance and listen to band music in their dinner hours. The women's indoor swimming pool was across the road from the rest of the recreation ground, adjoining the factory. It included such modern amenities as slipper baths, spray baths and hair-drying equipment.

One female worker remembered that they had an hour-long swimming lesson during the morning at continuation classes. Swimsuits were provided by the firm and colour-coded. Non-swimmers and weak swimmers wore red woollen costumes whereas intermediate swimmers wore blue and advanced swimmers wore navy blue.

The baths were in use all year round and were heated during the colder months with a steam system that also pumped the swimming pool water through an aerator. Because the men were only provided with an open-air pool, some times during the week were reserved for their use only in the indoor baths provided for the women. It was a condition of employment too that all boys and girls entering the factory should learn to swim.

From 1919 to 1924, about 75 acres of land roughly ½ mile from the works were gradually transformed into the Rowheath Playing Fields. Here there were eleven grounds provided for association football, three rugby grounds, seven hockey fields, eleven cricket pitches, three bowling greens, two croquet lawns, and forty-one lawn tennis courts. Nine acres was given over to a works garden club that enjoyed a pavilion, shrubberies and an ornamental water garden. There was also a shallow pool for children to sail their boats on as well as those of the works model yacht club. On Saturday afternoons, in one single season, more than 450 cricket games were played here. On another piece of land separate from the 75 acres were some allotments.

The Bournville Athletic Club was formed in 1896, and this replaced the small cricket teams and football clubs that existed at that time. There was also an angling section of the club from 1914, which met and

Rowheath Pavilion. (*Courtesy of Cadbury Archives and Mondelēz International*)

fished at a rented reservoir 10 miles away in Bromsgrove: Tardebigge Reservoir. The Bournville Girls' Athletic Club was formed in 1899, and they played cricket, lawn tennis, hockey, netball and water polo. Some members also taught swimming at various girls' clubs in Birmingham.

**Drama**

A dramatic society at Cadbury's was formed in 1912, although there had been performances before then. These had consisted of pageants and the first one took place in July 1908 at the works summer party. The show consisted of around 170 people and was received so well that they performed another the following year.

The inaugural meeting of the dramatic society was held in October 1912, when officers and a committee were elected. Performances were given at the new year party in 1913, including the play *Cophetua*, written by John Drinkwater. Drinkwater was the manager of the Birmingham Repertory Theatre. He went on to become a published poet and playwright. In June, the society gave their first public performance, attended by more than 500 people. *Cophetua* was repeated along with scenes from William Shakespeare's *Twelfth Night*.

The summer party was an annual outdoor event to which everyone who worked at the factory and their wives were invited. The first took place in June 1902, on the men's recreation ground when the pavilion was opened there. The firm ran a suggestion scheme and the prizes for this were awarded at the summer party. There was also a sports programme. The same format was continued and followed at every summer party until 1906. There was no summer party in 1907 due to the death of Richard Cadbury's widow. Then in 1908, it took place for the first time on the girls' recreation ground, where it continued until 1914, apart from in 1910, when the ground was undergoing alteration. Some sporting events continued on the men's recreation ground. After the First World War, the tradition ceased as there were by then too many employees to make it feasible.

## Music

Music was also popular with the workers at Bournville and may have originated at Bridge Street with the singing of hymns at morning prayers. In 1883, an orchestra of just six members started to meet in one of the employee's houses. In 1890, the orchestra was formally taken over by the firm and reorganised. At first anyone could join in, but when the company took it over, membership was restricted to people employed at Bournville. As the orchestra grew, it started to perform at other places in the district.

A musical society was formed in 1900 and, at first, consisted of a band, an orchestra and a choir. By 1930, it had expanded to include an orchestral society, an operatic section, a choral society, a silver band, a section for pianists and organists, and a male voice choir. At one time the firm also employed a musical director. Usually each section was run by a different conductor hired in from outside for a fee, although sometimes a keen amateur from within the works was also allowed to have a go.

Bournville Works Brass Band, c1881. (*Courtesy of Cadbury Archives and Mondelēz International*)

In 1925 and 1927, the choral section performed Handel's *Messiah*, and the operatic society performed several light operas by Gilbert and Sullivan as well as musical comedies. A great number of concerts were performed in a variety of places, including hospitals and prisons. At the factory, during the dinner hour, concerts were performed either in the new concert hall at the factory, built in 1927 complete with brand new organ, or outside in the fresh air.

The annual Bournville works music festival started in 1913, although it stopped again between 1915 and 1921. It was held on the girls' recreation ground and lasted for four days. Days one to three were strictly for factory employees, but the fourth day was thrown open to the general public. The festival consisted of a number of competitions for which a professional musician was hired as a judge. Competitions ranged from instrumental to vocal, from solo to groups and bands. There was also a choral contest for employees representing around twenty different departments. The audience numbered thousands.

Dancing was also popular. Folk dancing first took place in 1908 and Morris dancing was held two evenings a week. In 1923, a folk dance

society was started, affiliated to the English Folk Dance Society via its Birmingham branch.

## Summer camp

Continuation classes were only held during normal term-time at schools and other learning institutions. When those classes were closed for the holidays, the firm organised vacation schools for the younger workers. The holiday schools weren't just about learning, they were also about the benefits of fresh country air and exercise.

The first camp was held in 1914 and continued for some years. It was held at Rubery, about 9 miles outside Birmingham, and it lasted for four weeks. During this time between twenty-five and thirty boys turned up each week, a different group of boys each time. This means that more than a hundred boys benefited. Lessons included history, geography and geology as well as an introduction to the other industries and trades of the district. This illustrated to the boys an alternative life

Cricket match at Bournville, aerial view. (*Courtesy of Cadbury Archives and Mondelēz International*)

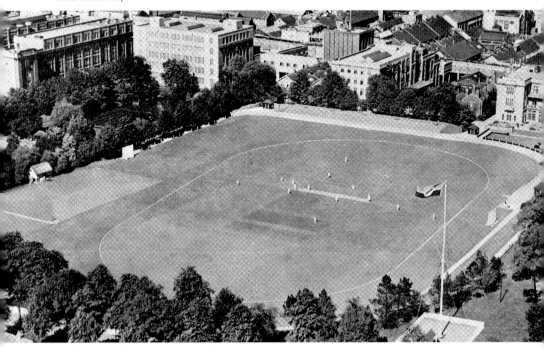

outside that offered by the chocolate factory, in case any would like to pursue a different path.

Birmingham is at the centre of a number of canals and a different type of holiday school was introduced. In 1917, the first ever voyage of 'the school on a barge' was made from Birmingham to Stratford-upon-Avon and back. The boys visited Stratford itself as well as Warwick Castle and the Edge Hill battlefield. Classes were held on the banks of the canal in fine weather or inside the barge if it rained. Before long, different canals were added to the curriculum and some boys made it as far as Oxford.

Another holiday school was started in the Wyre Forest in 1924. This time twelve lads were taken to the forest near Bewdley in Worcestershire. Here the boys were taught about camping, cooking, forestry and natural history. Sightseeing this time included Worcester Cathedral.

There weren't as many camps organised for the girls, although groups were taken to visit London for a week.

## Youth Club

In 1900, the youth club was started with the aim of providing the lads – no lasses – with sports, games, hobbies and interests, from chess to boat building to debating. The club consisted of two sections, one for under-18s and one for over-18s. Every youth employed by the firm automatically became a member, without having to pay a subscription fee. Members of the youth club, or Bournville Youth Club, to give it its proper title, worked with other boys' clubs around Birmingham. Towards the end of the 1920s, a disused pub in a poor part of Birmingham was bought and converted into a boys' club, run by young men from Bournville.

## Chapter 10

## Workers' Welfare

When they had taken over the floundering business in 1861, Richard and George worked just as hard and as long as their employees. In the speech made to a crowd including previous employees in January 1913, George recalled: 'Our working hours at that time were from 8 o'clock in the morning until 7:30 in the evening … Saturdays included.'

Yet they were one of the first companies to give their workers half-holidays: 'There was no factory in Birmingham, so far as I know, that closed on Saturday afternoons, and I believe we were the first to close at midday on Saturdays; people told us it would mean ruin. I do not think any men could have been happier.'

Bournville Works Fire Brigade, c1909. (*Courtesy of Cadbury Archives and Mondelēz International*)

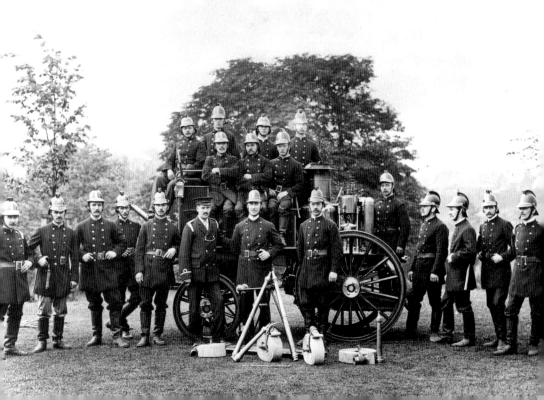

In 1879, the number of people employed at the factory had risen from twenty to about 230. Until this point, George had always made the effort to visit each and every member of staff who worked for them in their own home at least once a year. Plus, it was important to the brothers that they learnt all of their employees' first names, which added to the family feeling they instilled in the workforce.

The brothers felt a very strong sense of responsibility for their workers, morally, spiritually and physically. Instead of working in fancy offices above and away from their workers, they worked in tiny, cramped spaces and were constantly among their employees. They would often roll up their sleeves, so to speak, and work side-by-side with the people they employed. And while it was clear that they were in charge, they still nurtured a friendly relationship that resulted in a very high respect from their workers as well as loyalty.

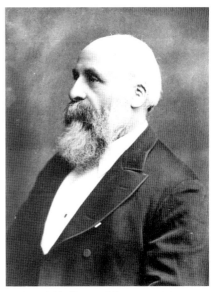

Richard Cadbury. (*Courtesy of Cadbury Archives and Mondelēz International*)

During the difficult period too, when they were struggling to revive the company, the brothers would often take their breakfast in the factory with the employees, and it is probably around then that the 'Morning Readings' first began. This started with the reading of a brief extract from some book the brothers thought might be suitable. But it soon progressed into daily prayers, a bible reading, and/or a hymn, and it lasted until 1912.

Conditions were soon to change for the workers, for the better, when a piece-work system was introduced. This resulted in better wages for the employees as well as a higher output from them. Financial incentives for punctuality or not eating the chocolate were also put into place. They were the first in Birmingham to introduce the weekly half-day off, as well as closing on bank holidays.

A circular sent to employees in 1865 stated that the hours from May to September that year would be from 6 o'clock in the morning until

2:30 in the afternoon, eight and a half hours, with half-an-hour for breakfast and twenty minutes for lunch:

> *This we do as a more convenient business arrangement. But we also believe it promotes the health and comfort of those employed—inducing habits of punctuality, early rising, and, what is more important, early retiring to rest; thus escaping much of the temptation which abounds during the late evening hours.*
>
> <div align="right">Circular to employees, 1865</div>

The working day had been shortened by three hours, despite the early start. As this applied during the summer months, perhaps the hot weather and its effect on the manufacture of chocolate had something to do with it as well as those reasons mentioned above.

Birmingham Slums. (*Courtesy of Cadbury Archives and Mondelēz International*)

When over-crowding became an issue in the streets surrounding the old Bridge Street works, the brothers decided to look for a more healthy environment for their workers. The new factory at Bournville included a garden and a playground, where there were swings and seats.

Employee dining rooms followed a few years after the move to the new factory, but Richard and George Cadbury had their own. The workers had dressing rooms too, one for the men and one for the women. And these dressing rooms were heated so they could be used as a drying room for wet boots and clothing.

Working conditions were very much improved, and employees hadn't had it so bad at the old factory in Bridge Street. But the new factory at Bournville, when they moved in during 1879, had its drawbacks as well. The heating, for example, wasn't efficient during the first winter, which was a very cold one by all accounts. Many of the rooms were heated by open fires, burning coke or coal. While this looked very nice, in some places the workers were far too hot. In others, they were far too cold.

Another problem was the location. Yes, the company had negotiated cheap rail fares for those workers who still came in from Birmingham. But when the factory was opening at 6 o'clock in the mornings, there wasn't even a train at that time from Birmingham to Stirchley Street and many started out at 4 o'clock in the morning for the 4-mile hike. This particular problem was solved when the rail company agreed to put on an extra train in the mornings, just for Bournville workers.

Many of the new workers were hired from the surrounding villages of Kings Norton, Stirchley and Selly Oak. These lived much closer to the factory and were able to walk in across the fields. On dark evenings, though, the girls were escorted back across the fields.

There were workers who lived much further afield, so accommodation was arranged for them in the surrounding villages and farms. Beds were also made up in suitable parts of the factory. One of the houses the company had built for staff was used as a hostel for the girls. Those who had permanent homes elsewhere would go home at the weekend.

When Cadbury's was converted to a private limited company at the end of the nineteenth century, the number of staff also increased, along with the size of the factory and surrounding buildings. Amongst the new employees was a Dr H. Richardson, who became the first works' medical officer in 1902, in what was to become known as the Works Medical Department. Three years later, in 1905, a works dentist

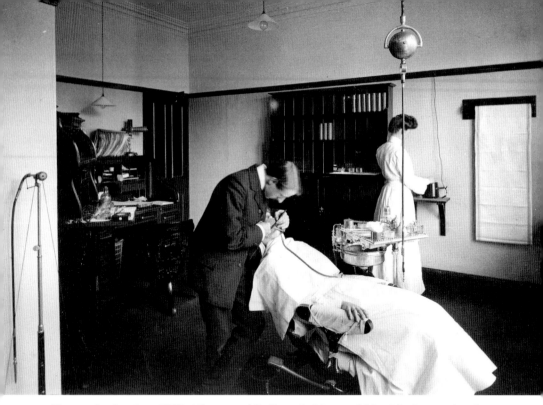

First works dentist, c1905. (*Courtesy of Cadbury Archives and Mondelēz International*)

was also appointed, so starting the new dental department. These days, we'd call the combined department occupational health – another example of the company's forward thinking.

In 1911, the idea of a female doctor was mooted as well, as the number of female workers had grown so much. However, by 1926 the company decided that they didn't need two doctors after all.

One custom at Cadbury's arose when a man or woman was to be married. He or she had a personal meeting with the chairman of the board and received a small wedding present. Of course, once married, women were expected to give up their job in order to attend to their new responsibilities. It was generally expected at that time that women would leave work upon their marriage in any case, but at Cadbury's it was a particular requirement that women, once married, should leave the organisation, and no married women should be employed. The only exceptions to this were part-time and temporary roles. It was George Cadbury who introduced this rule. He'd carried out a lot of work among the poor of Birmingham and he firmly believed that an idle man was more than happy to rely on his wife for money if she were working. But he also believed that a married woman could not look after her home and family properly if she worked in a factory.

Relations were so good between the owners and the workers, and pay and conditions were so fair, that historically there was no industrial action at Cadbury's, other than the General Strike of 1926, which wasn't internal but a response to outside influence. Not everyone at Cadbury's went on strike in 1926, however, and things could have been strained, to say the least, after the strike between those who'd joined in with the action and those who refused. But the works councils at the factory did so much sterling work that any minor bumps were ironed out before they escalated into anything nasty.

By 1929, industry had progressed to the extent that much of the work at the factory could now be handled by machines. The workforce dropped by around 3,000. Yet still the firm looked after their ex-employees by assuring that they had some financial support as well as encouragement in their quest for continued work elsewhere.

Example of a chocolate box. (© *Ian Wordsworth*)

# Chapter 11

# Pensions and Savings Schemes

Two separate pension funds were started at Cadbury's in the early 1900s, one for men, the other for women. The first was naturally larger than the latter due to the fact that women rarely served as long as men, and so didn't make as much of a contribution themselves during the time that they worked. In 1906, there were fewer than ten other companies in the country that contributed to a pension fund for their employees. The men's pension fund was started in June of that year on the basis that the firm and the employee would each make a contribution to the fund of equal value. The pension would be based on the earnings of the man during the time in which he himself was able to contribute. The retirement age was 60. One provision to the fund was that the money was not to be invested in the business of Cadbury Brothers Ltd. Another provision in 1922 was that the money should be invested in housing schemes for people connected to the works. The company made an initial donation of £75,000 to the fund. When a further donation of £60,000 was made, this was to cover those employees who had started work before the scheme began as well as to those who were above the age required for joining the scheme – although no age is stipulated. Both of these gifts were to help those earning up to £250 a year.

At first, membership of the pension scheme was voluntary, and any man between the age of 16 and 50 was eligible to join. However, the scheme was so popular that every eligible person actually became a member. Changes in income tax made membership compulsory, but as everyone was already a member, this didn't generate very much extra work at all.

The pension fund also served as a savings account for those workers who left the company before the age of retirement. These were able to withdraw their contributions plus interest, but the contribution the company made remained in the fund in order to boost what was left for anyone who did stay until retirement age.

Barrow Cadbury. (*Courtesy of Cadbury Archives and Mondelēz International*)

In 1914, a further gift of £13,000 from the firm was added to the fund to assist any man who earned more than £250 a year. Then, after the First World War, in 1920, another gift of £80,000 was made, this time to cover the rise in the cost of living since the end of the war. Of this, £50,000 was added to the men's fund while £30,000 was added to the women's fund. During that same year, some of the older men were given the option of increasing their contribution to twenty-five percent. The firm matched any who took advantage of this.

When the women's savings and pensions fund was started in 1911, there wasn't anything else like it in place anywhere in the country. For this, the age of eligibility was 15 to 43 and it included all female employees apart from part-time workers who earned less than 12s per week. The retirement age for this was 55 and the firm only contributed half of what the members contributed. This was because the majority of the women would use the fund as a savings scheme as most would leave the firm before they retired anyway, due to marriage. Again, if a member left before she reached retirement age, she was entitled to withdraw her own contributions plus interest, but the firm's contribution would remain within the fund.

Two more funds were started in 1923: a pensioners' widows' fund and a dependants' provident fund. Both were separate to the pensions funds, still on a contributions basis by both parties, and both were

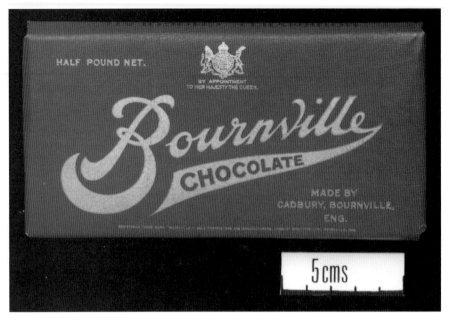

Bournville in the 1920s. (*Courtesy of Cadbury Archives and Mondelēz International*)

mandatory for all male workers over the age of 21. Like the pensions fund, however, the pensioners' widows' fund gave the member back his or her contributions plus compound interest at the time of his or her retirement, or at the time of leaving if they left the company before retirement age, less the firm's contributions. The dependants' provident fund was a death in service pension. This was calculated by taking the deceased member's total contributions and the interest that had compounded and the difference was paid to that person's representatives or dependants.

The pensioners' widows' fund was kick-started by the company with another generous gift of £60,000, which later rose to £95,000. The provident fund was seen as a complementary fund to the widows' fund.

Aside from these schemes, there was also a benevolent fund, which was provided by the firm and the works council, as well as grants given towards things like funeral expenses. There was also a workers' fund that covered expenses of a medical nature as well as home support for members' wives or other dependants in the form of 'home helps' if they were too sick to do the work for themselves.

Workers were encouraged to save money, either into a savings account or via some sort of life insurance. A savings fund was started by the

company in 1897. Employees made deposits of up to £20, upon which the firm paid a four percent interest rate. If, at the end of the year, the money was transferred to an actual recognised savings account, an additional one percent was added by the firm.

In 1920, the Birmingham Municipal Bank was established and a branch was opened up inside the Cadbury's works. Accounts at this bank replaced the savings fund.

## Sick pay and other funds

There existed at Cadbury's around this time a sick pay scheme. By 1919, this was another contributory scheme, a voluntary one contributed to by both the employee and the firm. But before then there was a non-contributory sick club. The firm also held its own health insurance. Accidents at work were dealt with quite differently. Where the accident was not due to the worker's negligence, his or her income was brought up to ninety percent of the usual wage at the firm's expense.

If a worker or his wife ended up in hospital, the firm covered the whole cost of the hospital stay in a public ward. If the patient were on a private ward or in a nursing home, the firm would pay 8 shillings a day. In 1928, however, Birmingham started a Hospital Saturday Fund, to which lots of different employees and their employers contributed. This money helped to finance the voluntary hospitals and convalescence

A fleet of delivery vehicles. (*Courtesy of Cadbury Archives and Mondelēz International*)

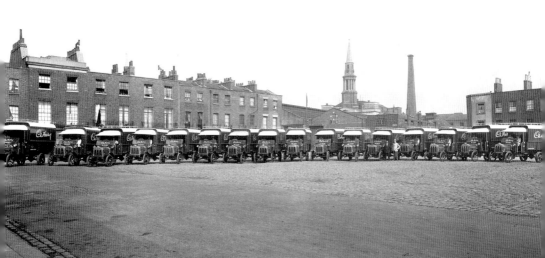

Example of a chocolate box. (© *Ian Wordsworth*)

Example of a chocolate box. (© *Ian Wordsworth*)

homes in the area, so that all workers who were members could be treated if necessary, as well as their families or dependants. When a patient needed urgent surgical treatment, the firm continued to help fund his or her private hospital stay, with contributions of their own as well as their workers, but also with the help of another fund – the Boeke Trust, which was set up by Richard Cadbury's daughter Beatrice and her husband.

In December 1920, the firm did something else to supplement the incomes of ex-employees. So long as the employee had not been guilty of misconduct, the company paid a benefit to that person for up to eighteen weeks if he or she couldn't find other work. For the first nine weeks, this was paid at a higher rate than for the second nine weeks. It was non-contributory as far as the employee was concerned. The amount paid depended on the worker's age and marital status and only applied to men, as married women weren't employed by the company.

Then, in 1923, a profit-sharing scheme was set-up, called the Prosperity Sharing Scheme. As management staff were already paid on a part-commission basis, it was decided to give other employees a share of the company profits. Whenever a dividend was paid on the ordinary shares of the company, a further dividend was also paid on a hypothetical block of ordinary shares imagined for the workers.

The total sum of money was then put aside to form a welfare fund, from which would be paid any 'short-time compensation' due to the normal working week being cut short for any reason not including holidays or industrial action. A flat rate was payable based on a standard scale of pay for general workers, but for boys under the age of 21, the flat rate was lowered.

Once any short-time had been paid, the remainder was then divided into a number of units that were then distributed among eligible employees based on age, length of service and, sometimes, gender. Eligible employees were over the age of 21 with at least five years' service, and they received one, two or three units.

This prosperity sharing scheme was funded out of company profits and did not form part of the general running costs of the factory. This meant the cost wasn't passed on to the consumer either.

# Chapter 12

# Bournville – a New Garden City

It is beyond the scope of this book to go into great detail of either the Garden City movement or the Bournville Village Trust and related societies. However, both feature so heavily in the history of the firm, and George Cadbury himself was a keen promoter of the movement, that to not cover any of it would be remiss.

The Garden City movement, a Utopian idea of living in an urban area surrounded by green land, didn't actually materialise in the United Kingdom until the very end of the nineteenth century. However, the Cadburys were there way before anyone else. In 1849, they were already considering what was termed a Model Parish Mission.

Initially this was for an alcohol- and tobacco-free village, in keeping with the Quaker way of life. But the Cadburys wanted to take things beyond just abstention. The village was to include the factory where the residents worked as well as schools, houses, cottages, farms and allotments. Aside from not drinking or smoking, the factory workers would be encouraged to contribute a part of their wages to:

> *... a fund from which, within a given period, they will become possessed of a Model Cottage as their little freehold, and also have a fund to fall back upon in seasons of sickness and old age, instead of taxing the sober and respectable portion of the community for their support.*
> *The Firm of Cadbury: 1831–1931*

Any land that fell vacant to the chosen parish would be bought and re-sold or re-let on the strict condition that there were no public houses or alcohol sellers anywhere within its immediate neighbourhood. Money was raised for this mission by, amongst other things, the sale of Model Parish Tea, Coffee and Cocoa. And it seems the cocoa part of this product at least was manufactured by Messrs Cadbury Brothers, Birmingham:

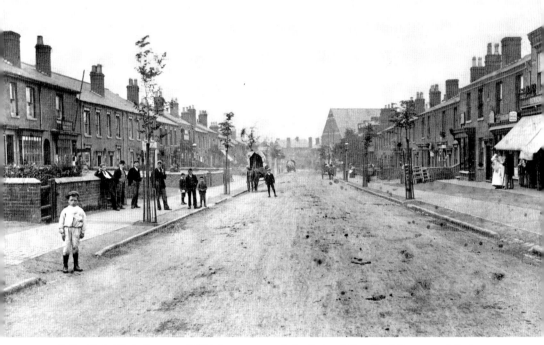

Selly Oak High Street, c1884 (now part of the Bristol Road). (*Courtesy of Cadbury Archives and Mondelēz International*)

*Who gave the tea and coffee is not clear, but the cocoa was manufactured by Messrs. Cadbury Brothers, Birmingham, who generously devote the whole of the profits from the sale of the above Cocoa to the Model Parish Mission, and have already remitted above £230 to the Treasurer.*

*The Firm of Cadbury: 1831–1931*

## Bournville

After moving into the new, purpose-built factory in 1879, Cadbury's purchased extra land in 1895 to extend the recreation facilities. In 1896, a further 12 acres was bought and a sports centre and cricket pitch were built. It was at this time that George Cadbury also acquired another piece of land that was to eventually become his beloved housing project.

Even at the time of the initial move to Bournville, a small number of houses had already been built. These were for the supervisory and senior members of staff, but they paved the way for what was to follow

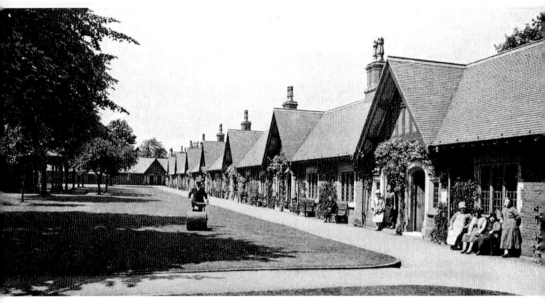

Almshouses. (*Courtesy of Cadbury Archives and Mondelēz International*)

more than forty years later. The majority of the houses built in 1879 were pulled down to make way for a new dining block in 1927. In 1931, there were still thirty-six houses on Selly Oak Road from this period. Today, the oldest surviving houses are in Mary Vale Road. These were built in 1895.

On the corner of Linden Road and Mary Vale Road, only a few hundred yards from the works, a group of almshouses was built. These buildings, which are still in existence today, were started in 1898 and were one of Richard Cadbury's last projects:

> *The almshouses themselves are thirty-three in number, each consisting of a living-room, with curtained-off bedroom, and a small kitchen, with other offices, and in some cases a small piece of garden, at the back.*
> *The Firm of Cadbury: 1831–1931*

Each property was designed for two people and furnished. There was also a common room on the development. The single-storey almshouses were grouped around a quadrangle, which consisted of lawns and flowerbeds. In the middle of the quadrangle was a clock tower. At the back of the properties was an orchard, which was for the use of the elderly residents.

To qualify to live there, residents had to be at least 60 years old and have some income – at least 10 shillings for single people, 15 shillings for couples, but not exceeding £100 or £120 respectively per year. They didn't have to be employees of Cadbury, but those who had been were given priority over those who had not. Thirty-eight houses adjoined the project, the rents of which went towards the upkeep of the almshouse foundation. Heating, lighting and medical care were provided free of charge to the residents of the almshouses.

Separate from these two projects was the Bournville Village Trust, which was actually also separate from the financial dealings and assets of Cadbury Brothers Ltd. This residential community was the personally financed brainchild of George Cadbury. For years he watched sadly as the poorer areas of Birmingham became steadily poorer. The effects of living in slum conditions on those who lived in them worried him deeply. He had already seen the success of the 'factory in a garden' at Bournville, and what a positive effect working in pleasant surroundings had on the people who worked there. As land became available for

Bournville Lane cottages, c1905. (*Courtesy of Cadbury Archives and Mondelēz International*)

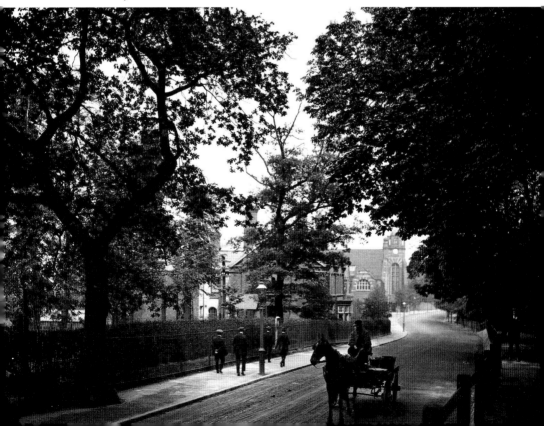

housing around the factory, George worried that those who had built the slums would snap it up and build yet more poor-quality housing. He believed the Cadbury's move into the country would have been a waste of time if the city caught up with the factory and continued to grow in close proximity.

One solution would have been for the company to buy up all the land and build houses for its workers, but that would 'tie' the properties to the factory, and George didn't really want that to happen. Instead, George – and Richard, who agreed with him – wanted to create a planned model village in which anyone could live, whether they worked at Cadbury's or not. He wanted the housing to be cheaply built but still of a suitable standard.

The first plot of land became available in 1893, adjoining the north and west sides of the factory. George Cadbury bought it at his own personal expense. Smaller pockets of land were bought in 1894 and 1895. By 1898 the area had doubled in size thanks to further land being bought between the works and Woodbrooke, where George had previously lived between 1880 and 1885. As other small plots were added, the final area covered 330 acres. By the end of 1900, George had built around 300 houses on the land closest to the factory. And on 14 December 1900, a deed of the estate was handed over to the new Bournville Village Trust charity. It was valued at £170,000.

The object of the charity was stated in the deed:

> *The amelioration of the conditions of the working-class and labouring population in and around Birmingham and elsewhere in Great Britain, by the provision of improved dwellings, with gardens and open spaces to be enjoyed therewith, and by giving them facilities, should the Trustees think it desirable to do so, for purchasing the necessaries of life, and by such other means as the Trustees may in their uncontrolled discretion think fit.*

Here it is clear that the properties were not solely for the use of employees of Cadbury Brothers Ltd, nor were the trustees restricted to activity in Bournville in Birmingham, but all over the country. The deed also went on to list certain powers possessed by the trustees, including the power to:

- buy, sell or lease land
- build, pull down or alter buildings
- borrow money on any terms

- give land and buildings for hospitals, schools or other purposes
- equip libraries, technical schools and recreation halls
- develop estates, directly or indirectly
- enter into arrangements for the joint working of property with other trusts, companies or private individuals
- employ staff
- make, alter or repeal bye-laws and regulations
- apply for acts of parliament
- invest money in suitable securities

George Cadbury only wanted buildings to occupy a quarter of the land on which they stood. The rest of the site should be kept for gardens or open spaces. If factories were erected, they should only occupy a fifteenth of the land they were to be built on. And a tenth of the land, not including the roads, should be laid down to parkland, recreation grounds and other open spaces.

But there was, of course, the one proscription*:*

*No property of the Trust, and no building erected upon it, was to be used 'for the manufacture, or sale, or co-operative distribution of any beer, wine, spirits or intoxicating liquor,' unless by the unanimous consent in writing of all the Trustees. These, however, are to bear in mind that the founder's 'intention that the sale, distribution, or consumption of intoxicating liquor shall be entirely suppressed if such suppression does not in the opinion of the Trustees lead to great evils.'*

*The Firm of Cadbury: 1831–1931*

Another clause of the deed stated that the administration of the trust should be 'wholly unsectarian and non-political', while the most important aspect was that profits were not to be distributed in any other way but were to be added to the trust or used for promotion of its work.

In 1903, around 150 acres were added to the trust, this time in Weoley Hill. In 1910, another 140 acres were added, this time in Northfield, and in 1929, more than 200 acres were added, in Shenley Fields. By 1930, the total area of land held by the Bournville Village Trust amounted to 1,060 acres, including the boys' and girls' recreation grounds adjoining the factory. These, 22 acres in all, were handed over to the trust by the company so that 'the character of these places may be safeguarded for the future'.

Maypole. (*Courtesy of Cadbury Archives and Mondelēz International*)

Of the 300 houses George Cadbury built in 1900, around 120 were let on 999-year leases. The cost of each of the leasehold cottages was about £250, and if someone wanted to buy a lease but couldn't quite afford to, a low-interest loan was made available, at a rate of three percent to someone who borrowed more than half the value of the house, and 2½ percent to someone who borrowed less than half the value of the house. Because some people took advantage of these long leases, selling their leases for up to thirty percent profit, George changed tack and any new houses were rented on short, weekly tenancies. Some houses were sold on 99-year leases, following a high demand.

The original village of Bournville, around 120 acres of it, was laid out to include parks, playgrounds, open spaces. Roads had trees planted on both sides. Schools had additional playing fields added to them. The houses had small front gardens but deep back gardens, all landscaped and planted for the residents when they moved in. There were fruit trees planted in gardens between the houses to give yet more leafy divisions.

Over the years a village green was added, surrounded by schools, a Friends' meeting house, an Anglican church (consecrated in 1925) and church hall, Ruskin Hall, and the Rest House. A fourteenth-

century manor house was taken down from its original site, brick by brick, and re-erected on the corner of two roads just a few yards from the triangular village green. Known in those days as Selly Manor, it became the home of the Bournville School of Arts and Crafts in 1911. Classes there included: drawing and painting, design, lettering and illumination, poster work, modelling, metalwork, enamelling, embroidery, dressmaking, weaving, dyeing, leather-craft and bookbinding, and they were organised by the Birmingham Education Committee.

The elementary school was built at the expense of Mr and Mrs George Cadbury. The local authority wanted him to build a school with classrooms large enough to hold fifty-five pupils to save on teachers' salaries. George Cadbury, however, was very firm. He wanted the classes to hold just forty-five pupils and took his argument to the education board, who upheld his complaint. This probably cost him much more money, in the long run. But at least his ideals were maintained.

A clock tower topped the elementary school and this is where the famous Bournville Carillon was housed (see Chapter 7). This gift was added in 1906, with extra bells added in 1924 and 1925 by George Cadbury Junior. There was also a series of frescoes on panels depicting scenes from the New Testament. The artists followed the medieval Italian and Flemish styles for these scenes, but also added images of Bournville into the background.

The Rest House is currently home to the carillon shop and visitor centre. It's an octagonal building standing in the centre of the village green. Paid for by the world-wide employees of Cadbury Brothers Ltd, the building was officially opened on 18 April 1914.

The whole Bournville estate consisted of 2,000 houses by 1930, and a community was created, not just for workers at the factory, but also for people who worked elsewhere. Houses of different values were built next to each other. The working classes lived cheek-by-jowl with the middle classes. The social experiment started by George Cadbury, and with the support of his brother Richard, seems to have been a success. They didn't want working-class folk huddled together in ugly houses in overcrowded streets. Those who couldn't afford to buy had been able to rent, although perhaps they paid a slightly higher rent to live here than in the slums closer to the city centre.

According to an article in the magazine *Boys & Girls*, by 1956 the Bournville estate housed 10,000 people. They didn't all work for Cadbury's either, as per George Cadbury's express wish that the houses would not be solely for factory workers:

> *When the experiment had proved a great success, George Cadbury transferred it to a Trust, and the income from the Estate is now used for building more houses and for housing and planning research. Today, 10,000 people live at Bournville—but less than half the houses there are occupied by people who work at Cadbury's. The Founder believed that it was wrong for a community to be dependent on one industry.*
>
> Boys & Girls No.80, September 1956

The experiment at Bournville was so successful, it made other garden cities such as Letchworth possible. Future town planning and legislation was based on the experience gained here.

## Chapter 13

# Cadbury's and the Slave Trade

The Cadburys were heavily involved in the abolition of the slave trade – and this would entail an entire book by itself. Briefly, however, by the 1900s, one would hope that the slave trade had been abolished and was illegal the world over. This was not the case in the Portuguese islands of San Thomé and Principe in the Gulf of Guinea, and a lawsuit followed, involving the firm of Cadbury and a London newspaper, which is also beyond the scope of this book to cover. The main points follow, though:

The Cadburys bought some of their cocoa beans from the markets in London and in Liverpool. Some of this cocoa came from these two islands, about 200 miles off the coast of West Africa. While William Cadbury, son of Richard Cadbury, was on a visit to Trinidad in 1901,

Nana Sir Ofori Atta I at Bournville, also Barrow Cadbury and William A. Cadbury. (*Courtesy of Cadbury Archives and Mondelēz International*)

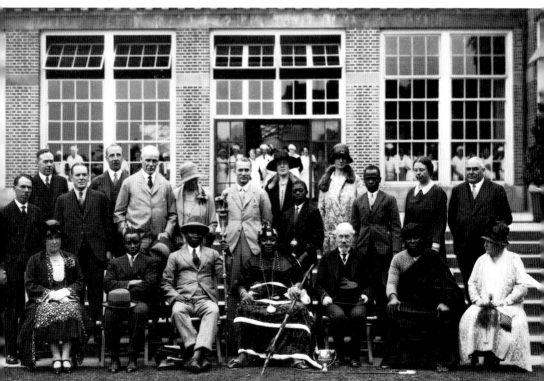

it was suggested to him that the working conditions in these islands amounted to little more than slavery. A few months later a letter arrived from Lisbon offering Cadbury's the opportunity to buy a plantation on San Thomé. This and others were politely declined. But the information that came with the letter suggested that the labour was considered an asset owned by the estate. In spring 1903, William Cadbury visited Lisbon in order to investigate.

Present at this meeting were representatives of the Association of Planters for San Thomé, who denied most strongly any suggestion of cruelty or oppression, and they invited the company to come out and visit the estate. The minister of marine and colonies, Senhor Gorjão, said that any abuses were 'trivial and unavoidable', and in any case would be removed by a law that had recently been passed, the Labour Decree of 29 January 1903. The British minister for Portugal, Sir Martin Gosselin, was also present, and he suggested allowing a year for this new law to be put into practice.

The Cadburys agreed with Sir Martin but kept an eye on things from a distance. Three other firms, Messers Fry & Sons of Bristol, Rowntree of York and Stollwerck of Cologne, joined with the Cadbury's campaign as they too were buying cocoa from San Thomé. Before the end of the year, when it was clear there had been no sign of reform, a member of the Society of Friends, Joseph Burtt, was sent to San Thomé to learn more. He was accompanied by a Dr W. Claude Horton from Birmingham. They also visited Angola and the hinterland in 1906, returning to England via Mozambique the following year.

Burtt wrote a report dated July 1907, which was countersigned by Dr Horton. From this report it was clear that conditions really were as William had been led to believe. Many of the workers in San Thomé and Principe had been captured in Angola, from where they were taken, in shackles, to the coast by slave-traders under terrible circumstances. They had been forced to sign contracts they couldn't read, as they were in Portuguese, which tied them to working for a number of years on either of the islands. At the end of the period, the contracts stated they were to be repatriated. In fact, not a single man or woman had been repatriated and children born in the islands didn't seem to have any right to leave either. The children were quite clearly the property of the estate owners where they worked. Mortality rates were high too, although good medical care was provided. After all, the estate owners wanted to keep their labour force fit and healthy and able to earn their keep. Burtt's report concluded:

*I am satisfied that under the serviçal [Portuguese for servitude] system as it exists at present, thousands of black men and women are, against their will, and often under circumstances of great cruelty, taken away every year from their homes and transported across the sea to work on unhealthy islands, from which they never return. If this is not slavery, I know of no word in the English language which correctly characterizes it.*

Burtt's report was presented to the British Foreign Office in July 1907, who then urged the cocoa manufacturers not to take any action or alert the press until the government had chance to discuss the findings with the Portuguese government. The Foreign Office was aware of the situation in 1905, when they had been unable to send out a representative and Joseph Burtt had been selected instead. The Portuguese colonial minister, Senhor Ayres de Ornellas, was out of the

Example of a chocolate box (closed). (© *Ian Wordsworth*)

Example of a chocolate box (open). (© *Ian Wordsworth*)

country at the time, so it was November 1907 before the government was able to send Sir Francis Villiers, who was by now the British minister for Portugal, having replaced Sir Martin Gosselin. Sir Francis presented the report to the Portuguese. At the same time Joseph Burtt and William Cadbury went to Lisbon themselves to present the report to representatives from San Thomé.

The Cadburys were also in frequent correspondence with the Anti-Slavery Society, the Aborigines Protection Society, and the Congo Reform Association – three of the most interested parties on the topic of African slavery at the time.

In September 1907, the African trade section of the Liverpool Chamber of Commerce passed a resolution urging the government to step in and help stamp out slavery in Angola, San Thomé and Principe. The resolution also requested that English firms should stop buying cocoa produced in San Thomé. Unfortunately, the Chamber of Commerce was unaware that the situation was already being looked into by the firms of Cadbury, Rowntree and Fry and members of the Foreign Office. Once they did hear about it, however, a further resolution was passed unanimously, saying that they were satisfied with the action being taken.

Unfortunately, the original resolution had already fallen into the hands of the press and reached Portugal. A pamphlet was promptly published in Lisbon, attacking the so-called integrity of Joseph Burtt and the British cocoa makers, even going so far as accusing the Cadburys and those associated with them of slander. The press-reading English public then attacked Cadbury Brothers Ltd for not doing something about the slavery immediately. Back in 1902, George Cadbury had used his own private capital and acquired a share in the Liberal paper the *Daily News*, so some rival newspapers found a great opportunity to accuse the Cadbury Brothers' chairman of hypocrisy.

At first, the Anti-Slavery Society and the Aborigines Protection Society both entirely supported the arrangement agreed with Sir Martin Gosselin. But as 1907 progressed and nothing seemed to be done, some members started to become impatient. They urged an immediate end to negotiations.

Also in September 1907, the *Daily Graphic* published a letter that included the extract: '... the Quaker houses had been called over and over again to the fact that they make their chocolate and cocoa powder from slave-grown cocoa, but they do not appear to care one pin.'

Later, however, on 24 October, the same paper issued the following notice:

*SLAVE-GROWN COCOA—AN APOLOGY ... So far as these firms are concerned, if, as alleged, they did not 'appear to care one pin,' the appearance was a false one and was due to the injunction of reticence laid upon them by the Foreign Office. As a fact, they have given serious attention for some years past to the conditions of labour in the Portuguese islands, and have spent some thousands of pounds in making investigations into the evils which undoubtedly existed.*

*It is evident that the three firms have suffered grave injustice ... We regret that we should have contributed to this injustice by giving publicity to a suggestion which proves to be quite contrary to fact, and we tender our apologies to the firms.*

In November/December 1907, Joseph Burtt and William Cadbury visited Lisbon to present the report, once again, to the Portuguese colonial minister and the San Thomé planters. The allegations against Burtt were withdrawn, and the planters were unable to deny what was alleged against them. Following this presentation, a statement was authorised for publication in England:

*The Government intends at once to make a thorough investigation of the whole subject in Angola, with the intention of replacing the present irresponsible recruiting agents by a proper Government system, as far as possible on the lines employed with success in Mozambique ... The system of recruiting will be such that it will also serve as a means of repatriation, and make it practicable for the native to return to his home in the interior.*

William and Joseph left Lisbon feeling reassured by the colonial minister. Indeed, they had no reason to doubt his promise of reform. However, less than three months after the meeting, the King of Portugal was murdered, in February 1908, and there followed a complete change of government. The new colonial minister, Vice-Admiral Augusto de Castilho, reviewed the previous government's pledge, and the cocoa manufacturers agreed to give them another year in which to put the reforms in place. By this time, the firm of Cadbury's had informed the Foreign Office that if drastic reform was not introduced, they would stop buying cocoa from San Thomé.

It was agreed that there would be no communication with the press on this subject until the year was up, and it was announced in the press in September 1908 that William Cadbury and Joseph Burtt were returning to Angola, San Thomé and Principe to investigate the situation again. A leader in the *Standard* on 26 September responded:

*We can only express our respectful surprise that Mr. Cadbury's voyage of discovery has been deferred so long. One might have supposed that Messrs. Cadbury would themselves have long ago ascertained the conditions and circumstances of those labourers on the west coast of Africa and the islands adjacent, who provide them with raw material. That precaution does not seem to have been taken ....*

As this clearly suggested that the Cadburys had known what was going on in the islands yet done nothing about it, legal advice was sought and a case for libel was entered in the High Court.

William Cadbury and Joseph Burtt landed on Principe in October 1908, from whence they continued to San Thomé, and then to Angola. Officials in both San Thomé and Angola refused both access and assistance, despite letters of introduction from the Portuguese government. The governor-general of Angola in fact said that he would receive the visitors on a private basis and not an official one. But it was already very clear that not one real reform had been attempted.

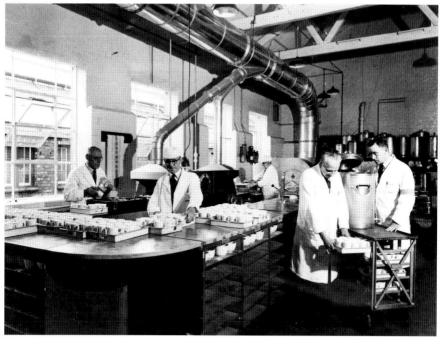

New tea-making point. (*Courtesy of Cadbury Archives and Mondelēz International*)

On their return to England, a communication was sent to the press that included the following:

> ... *Mr. Cadbury has found that no adequate steps have yet been taken to remedy the evils proved to exist ...*
>
> *His report has been carefully considered by the three firms on whose behalf he went out ... These firms have come to the conclusion that the time has now arrived when they must mark, by definite action, their disappointment at the failure of the Portuguese Government to fulfil the pledges of reform, on the strength of which they agreed for a time to continue commercial relations with the Islands.*
>
> *They have therefore decided not to make any further purchases of the cocoa produced in the Islands of S. Thomé and Principe.*
>
> *They will watch with sympathetic interest any efforts which may be made by the Portuguese Government or by the Estate Proprietors to remedy the evils of the existing system. They will be prepared to reconsider their decision as to purchase, when they are satisfied that such reforms have been carried out, as to secure to the indentured labourers from Angola, not merely on*

91

*paper but in actual fact, freedom in entering into the contract of service and full opportunity of returning to their homes when the contract expires.*

The next day Messrs Stollwerck of Cologne also issued a note to the press expressing their agreement with this action. Once the true facts had been revealed, each of the newspapers that previously charged George Cadbury withdrew its original accusation, going on to express appreciation at what the cocoa manufacturers had done.

In 1908, Joseph Burtt and William Cadbury witnessed the first four labourers working on the plantations returned to their native Loanda. By 1917, thousands were returning home.

In November 1909, the libel case finally came to trial at Birmingham Assizes. It lasted for seven days, with William Cadbury in the witness box for three of those days. The judge summed up very clearly in favour of Cadbury Brothers and even referred to a note that appeared in the *Standard*'s sister paper the *Evening Standard* published in May 1908, which commended the steps taken by the cocoa firms. Even though the jury found in Cadburys' favour, the company was only awarded damages of one farthing plus costs.

*Chapter 14*

# Works Magazines and Corporate Communication

The factory, the workforce, the product were all constantly growing, and interest in the business grew too. Outsiders were curious as to what was going on within these walls, and the workers were also interested to know what was going on around them. While for outsiders a new visitors' department was created in 1902 (see Chapter 2), to satisfy the curiosity of the Cadbury workers a works magazine was started. The magazine office was also the publication department, and a number of small brochures were published over the ensuing years, including one entitled *The Factory in a Garden*.

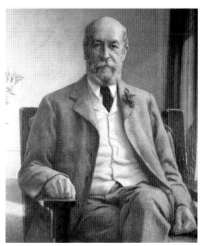

George Cadbury. (*Courtesy of Cadbury Archives and Mondelēz International*)

From 1918 onwards, new periodicals occasionally emerged from the publication department. One entitled *Farm and Factory* covered issues surrounding milk production and other agricultural matters, particularly of interest to those involved with the dairy farms that supplied the condensing and concentrating plants described in Chapter 2. Others are covered below or listed in the bibliography at the end of the book.

*The Bournville Works Magazine* was set-up to keep the employees at Bournville in touch with many business and social activities connected to the factory. In November 1902, the first edition appeared with the following on the very first page:

> *The* Bournville Works Magazine *is founded as the official record of the various branches of activity in connection with the Works. It will embrace*

*all departments, and it is the object of the paper to reflect as fully as possible*
*every aspect of the social and industrial life at Bournville.*

Things move on eventually, however. Requirements change, organisations get larger. After sixty-six years, in January 1969, the final edition of the magazine had changed to *BWM* with *BOURNVILLE WORKS MAGAZINE* as its sub-title. The cover had colour on it, and featured a photograph of the Right Honourable Barbara Castle MP, who had been speaking as secretary of state for employment and productivity at Bournville:

*This is the last issue of the "B.W.M." in its present form and under its*
*old title. Henceforth, as we explained in our last issue, the Bournville site*
*will have its own news service and its own newspaper—"The Bournville*
*Reporter", whose first number will appear very shortly.*

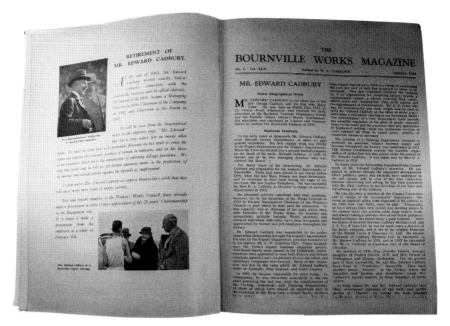

*Bournville Works Magazine,* January 1944. (© *Ian Wordsworth*)

> *"The Bournville Magazine", succeeding the old "B.W.M.", will serve the Group as a whole throughout the world. For some months to come, however, the "B.M." will look uncommonly like its predecessor, but as more and more Club and Council news items establish themselves in the "Bournville Reporter", the Group magazine will create a new tradition and a new style.*

As the new *Bournville Magazine* progressed, at the end of the 1960s, the covers became more garish and psychedelic in colour – navy blue and black, turquoise and purple, and cerise. It only lasted until March 1970, though, when another change was on the horizon:

> *No doubt many of us will feel sad at the end of the* Bournville Magazine, *so long associated with our past and present activities. However, it is no longer the most appropriate way of recording the development of the new Company.*

By now the company was called Cadbury Schweppes plc:

*In future, the* Bournville Reporter *will have a wider role to play, covering local news as before, but also carrying Company news in common with other local and re-styled Company newspapers.*

Beneath this contribution was a tribute to Tom Insull, who was editor, from Michael Cadbury:

The Bournville Magazine *now ends, but the work of Tom Insull, Editor since 1955, and of his staff will long be remembered. He has seen many changes at Bournville in his 49 years' varied service with the Company. His knowledge of the Company and its employees factually yet warmly stands out through thousands of pages of print. I am certain that the work of the Magazine has been very well done indeed.*

In 1981, the *Bournville Reporter* merged with the newspaper at Somerdale – *The Venturer* – and became *Cadbury News*. The first issue of the new paper explained:

*THIS is issue Number One of a new newspaper whose aim, quite simply, is to keep employees in touch with what is happening within the Cadbury confectionery business.*

*It is essential that Cadbury Limited operates as one big business rather than an assortment of separate factories and operations, each playing its part in isolation. It is important that the same information about the business is available at the same time to all confectionery employees.*

Other periodicals and newspapers included the following:

- *Foods Group News*
- *Tea & Foods Group News*
- *Cadbury Schweppes Special Report*
- *Beverages and Foods News*

Topics covered over the years included: the arrival of 1,500 parking spots in 1969, but drivers still preferring to park on the roads; a factory search for some missing canteen cutlery; a new messenger service in 1970; sport and leisure; rising canteen prices in 1974; the Birmingham pub bombings; rising costs in 1975 causing the company to tighten its belt and to ask the employees to buy shares; reasons why

we should or shouldn't join the EEC; how Bournville might look in the mid-eighties in 1981; electronic barriers installed in the car park; an employee buyout of the beverages and foods business in 1986; and the 90th birthday celebrations in 1998 for Bournville, the original plain chocolate.

CADBURY Brothers, Limited.

Cadbury's logo, c1905 onwards.

The last newspaper to roll off the presses was *Cadbury News* in October 1998. The issue led with the rebirth of the Cadbury Dairy Milk brand, Operation Purple Nation (see Chapter 6). There was no fanfare, no big announcement. This one limped out as quietly as it could with giant purple chocolate bars emblazoned across the front page. It had lasted seventeen years, but was now replaced with emails and e-newsletters.

Each and every edition of each and every periodical has been lovingly and carefully preserved in binders and can be viewed, by appointment, in the current archive department, the staff of which are always more than happy to oblige.

# Two World Wars

## The First World War

The summer of 1914 was a troublesome, turbulent one. With war breaking out at the end of July, the whole export side of the business changed. Overseas markets became more restricted and even disappeared in the enemy countries. By January 1915, the export of cocoa to some northern European countries was prohibited, and in February 1917, the export of both cocoa and chocolate was refused everywhere. This meant that some of those working on exports overseas, including the commercial travellers, were recalled to Bournville to help out with the reduction in the labour force there as others joined-up. Communication with the overseas customers was maintained and some travellers were retained, even though they didn't have a great deal to sell.

The entire Cadbury family were Quakers, and Quakers were and are generally pacifistic in their nature. Despite this, they didn't object to any man in their employment joining the armed services and fighting for his country. In fact, they promised to keep their jobs open for them for when they returned, and in the event they did for those who survived and were still able and willing to work. More than 2,000 men from the Cadbury works joined-up, 218 of whom were killed in, or as a result of, the conflict.

In response to the war, and in order to provide support to the ambulance service, the Quakers created an organisation called the Friends' Ambulance Unit. More than forty men from Cadbury's joined this unit. Some of the women went to help out in hospitals, and the Bournville Nursing Division was also formed. This division assisted in military hospitals at weekends, giving much-needed relief to those who worked there full-time. After the working day at the factory was complete, yet more women acted as district nurses.

One of the biggest things to happen at home for those not serving at the front was the collection and the creation of what were called

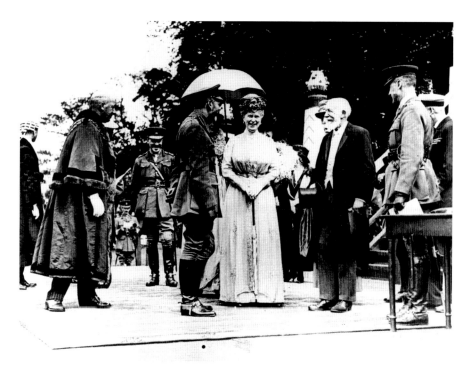

Royal visit. (*Courtesy of Cadbury Archives and Mondelēz International*)

'comforts'. Fundraising for the same was also very popular. These comforts consisted of simple things like socks to little luxuries, such as cake, tobacco and puddings, and they were parcelled up and sent out to the men serving abroad. Sometimes, the senders of the comforts would include a little hand-written note that could be read by the serviceman. The women of Cadbury's were no different, and aside from the nursing support they offered, they were also involved with sending comforts, usually to men from Bournville.

At the end of 1915, a newly formed committee oversaw the equipping and support of two hospitals. The Beeches and Fircroft Working Men's College accommodated seventy-two patients between them. More than £8,000 was subscribed by the works for maintenance of both hospitals. The Beeches was taken over by the Red Cross Society in March 1918 but Cadbury factory workers and staff still managed Fircroft until the autumn of 1919.

Another property belonging to the firm, Froome Bank, a girls' convalescent home in Bromyard in Herefordshire, was handed over to the military in December 1914. During the four years it was operational

as a military convalescent home, more than 1,200 patients were treated there.

Cadbury's had an ambulance unit separate from the Friends' Ambulance Unit and those members who were over military age formed a sub-division of the St John's Ambulance Brigade. The unit consisted of fifty or sixty members who worked mostly at night. They helped to transport the wounded from the ambulance trains to the hospitals, they provided refreshments to the ambulance trains that stopped at Snow Hill Station in Birmingham, and they helped to carry out orderly work at the hospitals. A hundred and forty men from the works became special constables, while the works' musical and dramatic societies were kept busy providing entertainment in hospitals and to wounded soldiers.

A number of grants and allowances were created to give financial support to men from Bournville serving in the armed forces and to their dependants left behind. Over the entire First World War this fund reached more than £94,000. It was administered and distributed by the Works War Relief Committee, which in turn was assisted by volunteers. The company also made a number of charitable donations that totalled nearly £110,000. Gifts were sent to the men serving at the front too, including 40,000 books.

All of this social philanthropy must not disguise the fact that, like many other companies during the First World War, business life for the firm of Cadbury Brothers Limited was very difficult. In fact, it makes their efforts all the more exemplary. The company depended on foreign imports for its supplies and many of its raw materials. The supply of sugar was particularly affected, as the chief source of this commodity originated in central Europe.

The labour force was constantly changing. Men leaving to serve abroad had to be replaced by those unfit for service, by those under or over military age, and – most interestingly at the time – by women. The women's suffrage movement was placed on hold for the duration of the war, but it was mainly the women who stepped in to do the men's work, despite those men at Bournville having their jobs kept open for them.

As a result of the war, the firm's products, or 'lines', were reduced. There had been 706 lines manufactured by the company at the beginning of 1914. By the end of 1915, only 195 survived. Advertising was reduced, although gramophone recordings were made of the Bournville Carillon during this wartime period. With the continued

shortage of sugar and milk, and government control over the manufacture of all foods, it is hardly surprising that the number of employees at Bournville reduced from 6,800 in 1914 to 4,900 by the end of the war.

The Frampton factory was diverted from the manufacture of milk chocolate to the production of condensed milk, butter and a cocoa/milk powder. By the end of 1916, all milk chocolate processing there had ceased. Cheese was made at the Knighton factory, and the company diversified into fruit pulp, dried vegetables and biscuits, for which a new fruit-canning factory was built in Worcestershire, at Badsey near Evesham, where the fruit was plentiful. These processes continued to be a part of the Cadbury's range until 1926, when the Badsey factory was taken over by the Littleton and Badsey Growers' Co-operative.

At the end of the First World War, more than 1,500 men returned to work at Cadbury's. When they did, they produced *Bournville Works and The War: A Record of the Services and Activities of the Employees and the Firm of Cadbury Brothers Limited, during 1914–1918.* This was originally twenty

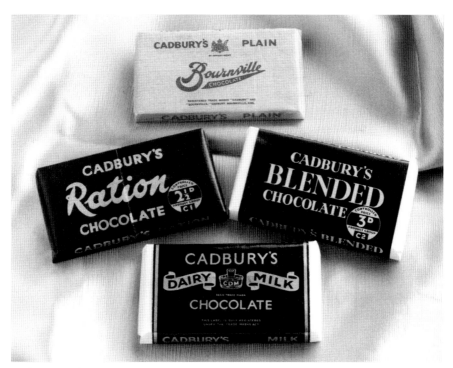

Various products (Ration Chocolate, Blended, Bournville and Cadbury's Dairy Milk). (*Courtesy of Cadbury Archives and Mondelēz International*)

pages longer than the reprinted sixteen-page version now available in the archives, but it was funded by the employees to express their gratitude for the way the company behaved during the Great War.

## The Second World War

At the time the Second World War broke out, the firm of Cadbury's were celebrating the centenary of George Cadbury's birth. There had been talk of the possibility of war as early as 1937, according to a statement made at a meeting of the men's shop committee in 1940 and reproduced in the *Bournville Works Magazine*.

In 1940, a new company called 'Bournville Utilities' was set up, 'with the idea of utilising the plant, tools, craftmanship, and technical and administrative ability available at Bournville in such a way that it would make a direct contribution to the country's military needs':

> *In particular, this was felt on the engineering side of the organisation. Before the war Bournville had a thousand tradesmen and technicians of all grades and every variety of experience. Some of these had left to serve in the Forces or in munitions works, but there were many who were bound to Bournville by ties of affection, pension considerations, domestic responsibilities, or house location, but who wished to do something more directly for the nation's war effort, yet without severing their connection with the Firm.*
>
> <div align="right">*Bournville Utilities: a War Record*</div>

Jobs taken on by this new utilities company included filling rockets with cordite, which fortunately resulted in no serious accidents. Milling machines were built for the new rifle factories and machinery was built for Joseph Lucas Ltd, who also occupied Cadbury's floorspace building substructures for Spitfires. Extra machine tools were installed so that parts could be made for guns and aeroplanes:

> *Altogether, from first to last, some 24 girls and 150 men and youths were employed in this section.*
>
> *A feature of the work was the readiness—characteristic of the people of the whole country—with which Bournville employees adapted themselves to jobs very different from their peacetime avocations. Girls normally employed as chocolate coverers, packers, decorators, etc., many of whom*

*had been accustomed to simple work on belt-conveyor processes, undertook mechanical operations requiring a very different technique and, often, considerable physical strength.*

*Bournville Utilities: a War Record*

The sheet metal department was able to switch manufacture from ventilator ducts and utensils to pilots' seats for Defiant fighters, forward junction boxes for Wellington bombers, and gun turrets for Stirling bombers. The mould-making department made cases for aeroplane flares, ribs for Spitfires, and a top-secret part nicknamed a 'paraffin can'. Later, these and other departments also started to make parts for

Royal visit. (*Courtesy of Cadbury Archives and Mondelēz International*)

Halifax and Lancaster bombers and Barracuda seaplanes. And they made rivets. Lots of rivets:

> *The work done by Bournville Utilities' Aero Sections as a whole covered details and sub-assemblies for embodiment in a dozen different types of aircraft. Over 30,000,000 rivets were used in aero work alone.*
>
> Bournville Utilities: a War Record

When Dunlop had to concentrate on making tyres, Bournville Utilities took over the manufacture of a rubberised material that covered the petrol tanks of aeroplanes, sealing itself when the tank was perforated by machine-gunfire and anti-aircraft fire. The rubber would swell as soon as it came into contact with petrol, keeping itself in position, so plugging any gaps. Sheets of rubber arrived at the factory in rolls, which was cut to fit the petrol tanks that were also received at the factory. Several layers were applied to the tanks, using a special adhesive. Corners and edges were tidied up so that a neat job was done. Then the tanks were taken on a cradle to another room where a finishing spray was applied.

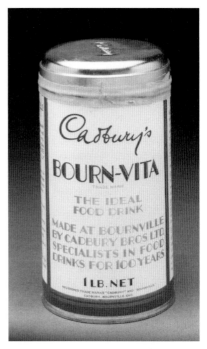

Bourn-Vita tin. (*Courtesy of Cadbury Archives and Mondelēz International*)

Tank covering was just as dangerous as filling rockets with cordite, due to the fire risk. Sometimes the material caught fire, due to the static that built up in the layers. But the workers were well trained to deal with such emergencies and there was little damage:

> *The filling of Anti-Aircraft Rockets seems most remote from Bournville's peace-time jobs. And yet it was not so very remote after all. It was just the packing of a new kind of Assortment Box. But the contents were dangerous, and they had to be so accurately packed that they were X-rayed to see if all the components were present and correct before they left the premises.*
>
> Bournville Utilities: a War Record

There were fortunately only three air-raids on the city for the duration. But instead of going to the air-raid shelters provided, the girls stood outside cheering as the anti-aircraft rockets they'd helped to build defended Birmingham. During the Birmingham Blitz, however, the factory flooded when a nearby canal was hit by a German bomb.

The biggest war job carried out by the Cadbury factory was the assembly of 5,117,039 service respirators and 6,335,454 canisters. It was also the first war job for which women were employed in considerable numbers. Jerrycans were made here, and the girls' swimming baths were used to store uniforms for the military. The Friends' Ambulance Unit formed during the First World War also re-formed for the Second World War.

During the war, married women whose husbands were away were allowed to continue working at the factory. When their husbands or boyfriends were home, however, the men could often be seen holding hands with their wives and girlfriends and chatting during the girls' dinner breaks. The confectionery department was closed down. This was due to milk and sugar shortages, other ingredients becoming hard to get, and food rationing. Most of the young men at Cadbury's were called-up while many of the young women moved elsewhere to carry out war work. Some of the women stayed and either did the jobs the men had left or 'did their bit' for the war effort in the comfort of their own factory.

All of this just scratches the surface of what the company did. They were involved with national war relief, helped Belgian refugees, sent chocolates to French children, took an active part in the Dig for Victory campaign, prepared Christmas parcels, sent chocolate to the families of men serving away from home, joined in with the knitting of socks and scarves. And they gave blood too. But when the workers – men and women – returned to Bournville after the war, their jobs and pensions were intact.

## Chapter 16

## Between the Wars

Following the merger with Messrs J.S. Fry and Sons in January 1919 (announced to staff in October 1918), the first event of significance occurred on 21 May 1919. For on that afternoon, King George V and Queen Mary visited Bournville. George Cadbury was presented to the royal visitors by the Lord Mayor of Birmingham in front of a huge crowd that had assembled on the men's recreation ground. The king decorated a number of men who worked at Bournville and had served during the war, and then he and the queen were escorted on a short tour of the girls' recreation ground, the almshouses, and a number of other premises in the village.

After the First World War, the Cadbury board was expanded as more of the younger generation of the family joined the company. Walter Barrow had already joined in February 1918, but two more were added in 1919: George's fourth son, Laurence J. Cadbury, who had

Bournville. (*Courtesy of Cadbury Archives and Mondelēz International*)

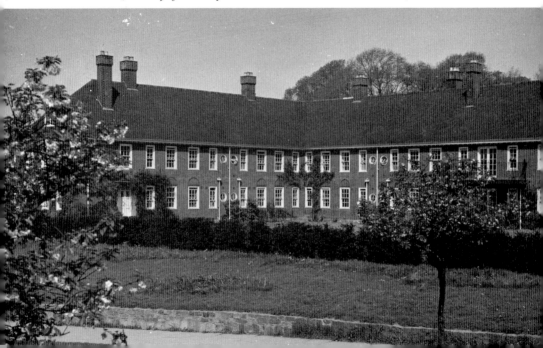

returned that spring from France; and the daughter of his nephew Barrow Cadbury – Dorothy A. Cadbury – a great-granddaughter of John Cadbury. She was the first of the fourth generation of Cadburys in the business since John opened his shop in Bull Street in 1824.

Dorothy Cadbury originally came to the firm in 1917 in order to learn about industrial conditions. She started as a factory hand. However, in 1918, after she had displayed an aptitude for management, she succeeded a Miss Pumphrey as works forewoman. When she joined the board, she assumed control of all of the women's departments, which had previously been managed by her uncle, Edward Cadbury. Laurence Cadbury took over responsibility for factory management and development in the men's departments.

In 1919, William A. Cadbury, Richard Cadbury's son, was made Lord Mayor of Birmingham. As this was to take up a lot of his time for the next two years, much of his responsibility at the firm was handed over to his nephew, Paul S. Cadbury. Paul was the son of Barrow Cadbury, and the brother of Dorothy.

Cocoa block, c1926. (*Courtesy of Cadbury Archives and Mondelēz International*)

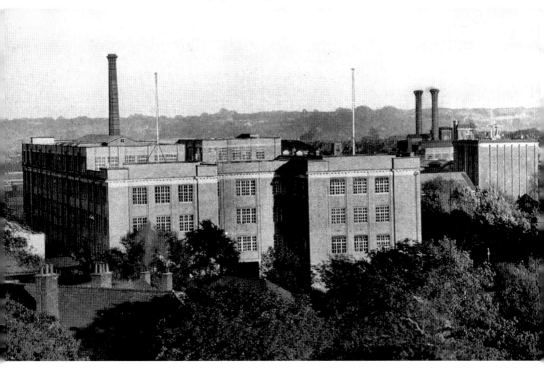

It was during the 1920s that the firm started to recruit employees from universities. Until now, they had mostly climbed up the ranks from within. Under the supervision of Dorothy Cadbury, more women were recruited into the higher end of the administration and business. Men who would normally have retired had stayed with the company during the war years, due to a lack of younger men. Now was the time for these experienced old hands to leave the company and make way for a youthful workforce again.

The merger with J.S. Fry and Sons meant that the company now used the same distribution depots they had shared when they were separate entities, as well as some they didn't share but were geographically close to each other. These depots had been set up so that the customer did not have to wait so long for a delivery. In 1929, the transport department became a joint one for both Fry and Cadbury. By 1930, Cadbury had established fifteen of these depots, all across the country, and in Dublin and Belfast. Most of these adjoined a railway siding. Some had showrooms. Where there were two depots in one place, one bigger than the other, such as in Liverpool, the bigger one was adopted and the smaller one closed. Where the two companies had previously shared the same premises, such as in Newcastle, it was retained. And where one firm didn't have a presence previously, such as Fry's in Dublin, they now did. Each company retained its own identity on the delivery vans, with the number of Cadbury vans and the number of Fry vans proportional to their individual share of the business.

These new depots came under the new transport department, as did the management of rail traffic and canal traffic. The firm once had its own fleet of barges for use on the canals, but these were sold when it became more cost effective to sub-contract the work to other canal carriers.

By 1929, 91,000 visitors were being received at the factory at Bournville each year, and a visitors department was also set up within the transport section to help manage this. The firm even arranged for rail excursions to visit the factory. In 1929, thirty-five such excursion trains brought visitors to Bournville. The visitors were taken by guide around the grounds, driven in a coach through the village, and entertained to tea. There were 120 visitor guides working around the factory. In the past, visitors to Cadbury's had been personal friends and associates of the family. Now members of the general public were included.

Deliveries were sent out in bulk from the factories to the depots in wooden packing crates, and then distributed locally to the retailers. Only

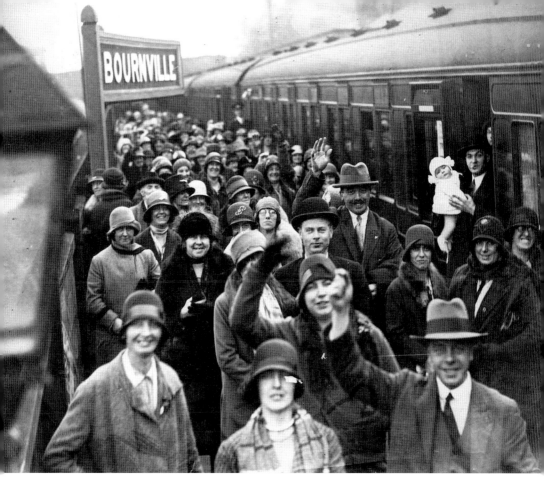

Excursion from Derby 1929. (*Courtesy of Cadbury Archives and Mondelēz International*)

these bulk deliveries were made in wooden packing crates, however. The smaller packing boxes had been replaced by cardboard, and that meant there was less need for a sawmill at Bournville. Following a fire in 1919, and because of the need for more space, a new factory was purchased in Blackpole in 1921, about 1½ miles from Worcester. The new factory was commutable to Bournville via road, rail and canal. The first departments to be transferred there were the timber yards and sawmills and, in July 1922, the first machinery started to operate there. In January 1923, the tin-stamping shop and the tin store relocated to Blackpole, followed later that year by the nut department.

Cardboard, straw-board and paper started to be stored at Blackpole at much the same time. By 1927, it also housed some of the advertising department. The new factory stood on 150 acres of land on either side of the Great Western Railway line, with good access to the Birmingham and Worcester Canal. This canal meant that the new premises was also connected to Frampton. The staff there had their own sick benefit

Lily pond, girls' grounds 1938. (*Courtesy of Cadbury Archives and Mondelēz International*)

fund but could still contribute to the Bournville pension fund. They had their own men's and women's work committees, just as they did at Bournville, and they had their own social and athletic club. Here, on 10 acres of land, they could enjoy football, bowls, cricket and lawn tennis, and there was a recreation hut there for indoor functions as well as canteens for both the men and the women.

Once the factory at Bournville was relieved of these functions, development continued there. The confectionery, moulding and cocoa blocks were added, as well as a dining building, built on the site of the last of the original cottages at Bournville that had been demolished in August 1914. Because of the war, however, the dining block was not fully completed until 1927. Accommodation included changing room facilities, a library and a rest room. There were also a club room and visitor facilities.

The dental department expanded in the years immediately following the First World War. The staff was increased to three fully qualified

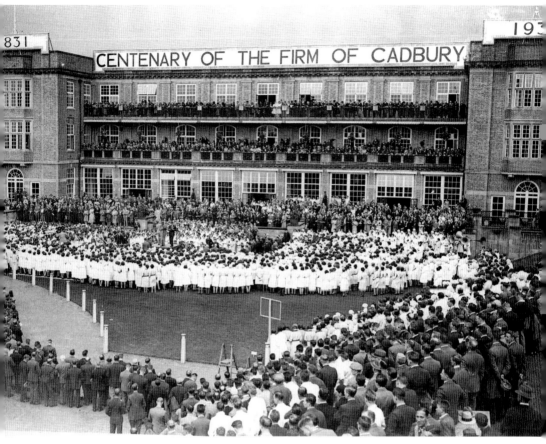

Celebrating the centenary at Bournville in 1931. (*Courtesy of Cadbury Archives and Mondelēz International*)

dentists, a mechanic and five dental nurses. Of an evening, outside dentists were also able to come into the works to treat the workers. The main objective of the dental department was to get school leavers to have their teeth checked as they came to work at the factory. Any dental treatment required was then made a condition of employment up to the age of 18. For those who were still under the age of 16, toothbrushes and tooth powder were also provided free of charge in a bid to encourage good dental hygiene. These were then offered at a low price to encourage continuation of the new regime. Dental nurses and PT instructors would inspect workers' teeth at periodic intervals. In 1923, the percentage of teeth passed as perfectly clean were forty-four percent for the boys and fifty-two percent for the girls. By 1930,

this had risen to seventy-seven percent for the boys, and ninety-three percent for the girls – so yet another successful endeavour on the part of the company.

There was also a remedial medical scheme in place during this period. This was where workers who seemed in not-too-great health were reported by their colleagues via the shop committees to the medical officer. The medical officer would then carry out an examination, and if the worker was indeed in poor health, he or she would be passed on to a doctor. If, however, the worker was simply run down or in need of some rest, he or she would be sent for a fortnight's recuperation at one of the company's convalescent homes. There was one such home for the women in Bromyard, near Worcester, and one for the men in Harlech in Wales. These patients didn't have to pay for their treatment or their transport to the home. That was covered by the company. But nor were they paid for this time away from work. Instead, if there were dependants, the company paid an allowance.

*Chapter 17*

# Voices from the Past

## Memories of Bridge Street and early Bournville

In September 1909, the *Bournville Works Magazine* commemorated thirty years since George and Richard Cadbury vacated the Bridge Street factory and moved to Bournville. The article included a few reminiscences, of which there are extracts below:

> *George R. Truman*
> *When I entered the service of Cadbury Brothers, in 1862, being their first clerk, the number of employees was twenty-five all told. William Talliss was there a few months previously. Mary Brown had been employed for four*

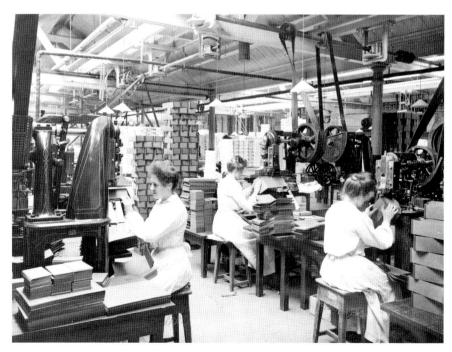

Early box making at Bournville. (*Courtesy of Cadbury Archives and Mondelēz International*)

*years, and is the oldest hand, and the only one who remembers Mr. George Cadbury coming into the business. After three years I took a journey in North Wales for Mr. George Cadbury, who eventually gave the ground to me. At the height of my travels I covered six counties in North Wales, the Isle of Man, Birmingham, and sometimes the Channel Islands ... I was the first to take orders for Cocoa Essence.*

*David Jones*
*In 1867 the Bridge Street office was the size of an ordinary kitchen. ... Mr. Richard Cadbury's and Mr. George Cadbury's offices (partitioned off) were up the stone steps above us. ... Up to this time the tea and coffee trade was the most important, and was under Mr. Richard Cadbury's care. About that time Mr. Richard travelled to Gloucester, Bristol, Clifton, and Bath. Mr. George worked Herefordshire and Wales, with occasional journeys to other parts of England, and Mr. Henry, Dorset, Hampshire, the Isle of Wight, Kent, Surrey, Sussex, and the West of England.*

*[A]t that time there were only two packers. Cocoa Essence was a new baby, and required a deal of nursing before it took to walking; but it was a baby highly esteemed, and Bournville would have been unknown to us and the world if it had not been for the fertile brains of Richard and George Cadbury.*

*There had been a steady growth in trade up to Christmas, 1874, when a sweeping change took place. The tea and coffee trade was given up, and the Homoeopathic, Rock, Iceland Moss, Breakfast, Pearl, and Gem Cocoas were no longer sold—only pure cocoa being now made.*

*... In 1875 there was a great increase in the sale of Cocoa Essence, Mexican and other Chocolates. In 1876 I more than doubled my turnover of 1875.*

*Henry Brewin*
*... In 1866, the year my connection with the Firm commenced, there were not more than twenty men and boys employed. It is gratifying to recall that in those days, as now, the happiness and recreation of the employees was one of the chief aims of the Firm. It was customary then, as to-day, for cricket to take a prominent part, and we used to play in Sturge's field, near Wheeley's Road. I remember one match in particular, when it came to my turn to take the bat, the late Mr. Richard Cadbury being the bowler. He was very fond of the game, and could bowl a very swift ball.*

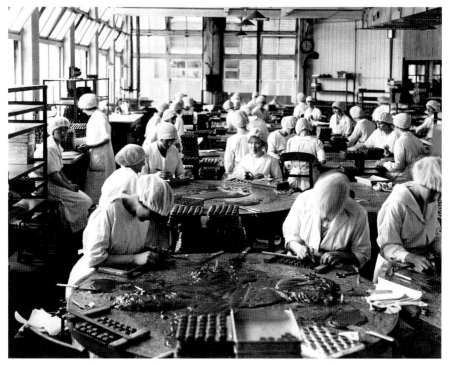

Early production at Bournville. (*Courtesy of Cadbury Archives and Mondelēz International*)

*T. King*
*… When I first went to work at Bridge Street, in 1869, there were four roasting machines, [on] which I roasted 1 cwt. at a time, but two of them were used to roast coffee and chicory. I should think we roasted about 10 or 12 cwts. per day of cocoa; one man and a boy were employed roasting, and instead of having machines for cleaning the raw cocoa, two women sieved and picked it by hand. I think we should want 400 or 500 to pick the quantity we roast now.*

*… Mr. George bought the boys a bicycle, of the bone-shaker type, which we used to learn to ride at dinner-time, in Bridge Street; then those who had learnt to to ride had the privilege of taking it home in turns.*

## The Reminiscences Book

In 1929, for the Bournville factory golden jubilee, sixty-three men and women, including members of the Cadbury family, wrote of their

memories working at both Bridge Street and Bournville. They either typed or hand-wrote their memories on lined, foolscap pages. Some chose to use their own writing materials, and these letters were bound with all the others in a giant leather book.

The letters and reminiscences provide a glorious mix of what it was like to work at the two factories between 1879 and 1899 as well as a social history of life in Birmingham. There are also some perceptions of the Cadbury family from those who worked for and with them.

All of these letters have been lovingly cared for by the archives department and are in a binder that is affectionately known as the *Reminiscences Book*. Here is an edited selection of what some of those people remembered, as they were written:

*Louis Barrow (no date)*
*Of the original Cadbury brothers, I have a very vivid and pleasant recollection.*

*Benjamin, appeared to me to be a quiet, kind and a good looking man.*

*With regard to John Cadbury, we used, as boys, to see him very often, particularly at the high teas to which, if I remember right, we were invited every week to his house in Harborne Road.*

*I cannot remember the Factory at Crooked Lane at all, but I remember Bridge Street very well, particularly the entrance from the road where, at one time they were able to show us some large boa constrictors which had been sent from abroad.*

*… When the Firm came to Bournville, it seemed a wonderful place to visit. We were frequent visitors to the new Factory, and both George and Richard Cadbury always seemed pleased to see us and to spare time to show us over the Works and explain anything we wanted to know. In fact, in those days, I sometimes wondered whether George and Richard ever did any work at all. It seemed to me to be all holiday and a sort of fairyland factory.*

*… At Easter, 1900, I entered the employment of Cadbury Brothers, as Engineer. I was taken around the Works by W.A. Cadbury, who impressed on me the great importance of thoroughly understanding the manufacture of cocoa and chocolate as it was then carried out. He insisted … that the function of an engineer at Bournville was to apply any Engineering knowledge he possessed to the improvement in the manufacture of the actual good produced. This principle has always been with me during the whole of my period of service.*

*W.A. Cadbury was very particular as to how certain details of engineering work had to be carried out. For instance, he told me that he always himself*

*personally measured up all the iron plates which were put down on floors (for the easy transit of trolleys), and asked me always to measure them up personally and see that when they were ordered, the sizes were quite correct.*

*… When the Drawing Office was first started near No. 1. Engine, I only had Edwin Fasham to help me. I soon found that he was no good at drawing, although he made an excellent buyer. … As the years went by, the Drawing Office got bigger and bigger, and I used often to apologise to George Cadbury for the size of it … I used to argue that it was better for an office to be on the small side. … I do not think George Cadbury, Junr. quite approved. On the contrary, he was always encouraging us all to make preparations for a larger output. When we started making Milk, the output was about 5 tons per week, and we conceived the idea of condensing Milk at Bournville and then drying the crumb in heated air and so making Milk Chocolate. When we designed the building … it could give an output of 40 tons per week. This, we both thought, was quite impossible, but we nevertheless went forward with our plans. As events turned out, we need not have been at all frightened at this figure.*

*C.H. Brown (7 February 1929)*
*I came to Bournville in the Autumn of 1889. The Firm in those days was not a Limited Company, and the chiefs were – Mr. Richard Cadbury, Mr. George Cadbury …*

*I went straight into the Export Office as a Junior of eighteen years of age, and the entire Export Office Staff then numbered six. The Office had recently been opened as an extension of the General Office, which, with about twenty five clerks, was then getting overcrowded. In addition to our Export work we also took on some of the overflow from the General Office, and before long we were helping them to the extent of doing Birmingham, North Wales, Manchester, Scotch and Irish trade.*

*At that time there were no such things as Fountain Pens, Telephones or Typewriters. All letters and invoices were hand-written and press copied. Communication with the outside world was not possible, but by means of a tube with whistle attached we could speak to the General Office and the Stockroom.*

*Letter opening in the mornings was almost invariably done by Mr. Richard himself and his sons, the letters having previously arrived at Bournville in a one-horse van, which was also used for delivering all Birmingham orders, and incidentally for bringing Mr. Richard Cadbury to the Works form the junction of Dogpool Lane with Tenacre.*

*In those days Mr. Richard lived at Moseley Hall, and used to walk from there to where the van picked him up.*

*... I had a walk of an hour and ten minutes from Sparkbrook through Moseley and Dogpool. [After] a year or so I got rather tired of this walk, and can claim to be one of the pioneers in arriving at work on wheels. This was only a modest cushion tyred bicycle, for which, however, there was no accommodation provided, and I used to leave it at a cottage at the end of Bournville Lane for a rental of 2d per week.*

*... I can well remember the immense excitement which pervaded the Offices when the Travellers came in [for their annual conference]. It was an adventure in those days to come from Ireland or the North of Scotland, and the presence of all these men at the same time gave us quite a thrill ... they seemed a race apart and were looked upon with considerable awe.*

*[The office spring outing] used to be held on the banks of Cofton Reservoir. I can still remember the large helpings of home cured ham and new laid eggs which were put away by some of us on those occasions. Even then we had one or two aristocrats on the Staff who did not care about the walk, and regularly once a year used to hire a one-horse four wheeler to drive them from Kings Norton.*

*... Our Athletic Ground was a very sloping field on what is at present the left-hand side of the Linden Road from the Old Farm Inn down to the brook. Here we used to play Cricket in the summer and Football in the winter, and when the Export Office got large enough we used to have many hefty battles with the General [office]. These usually took place in the dinner-hour, and I often wonder how we managed to survive the three-quarters of an hour dashing about, probably on the top of a pork dinner, and are still alive to tell the tale.*

*... The development of the Export trade became more rapid after the advent of Mr. Edward Cadbury, who took over the Export Department about 1895. Just about that time we further increased our representation abroad by sending Mr. R.B. Brown to South [Africa] and Mr. J.E. Davies to India. These two did splendid pioneer work for the Firm.*

*Barrow Cadbury (11 February 1929)*
*My recollections of the business go back about 60 years. Of Bridge Street I can remember my father's tiny office on the ground floor, the old beam engine which drove the whole of the machinery and the small handful of workpeople, each known and spoken of by the Christian names. ... As a child I remember playing with cocoa beans which my father had brought home. Absence from home in Germany from 1873-75, and then in 1881*

*apprenticed to our Cocoa Brokers, Messrs Woodhouse in London for over a year cut me off from home happenings.*

*From 1878 onwards I have however clear recollections about Bournville, the excitement about its purchase, the plans for the buildings. … Mrs Duffield's small cottage with its little garden on Bournbrook Lane formed the social centre where we met for meals, while the factory was being built – the old pear tree outside G.C's office being all that is left to indicate the site of her garden. Much stiff clay was met with during building operations, and the suitability of the soil for growing roses which grew freely in the garden outside the two offices occupied by Richard & George Cadbury. From this garden supplies of roses were sent weekly during the season to the Grocery Exchange at Manchester for our customers, thus early proving that Bournville was literally a factory in a garden. Roses have always thriven well at Bournville.*

*… There being no facilities in this outlying place for meals, facilities were given for employees to cook their own food on gas rings, etc. and the housing question had also to be tackled. At first there was almost the entire unwillingness on the part of the men to move into the country, and the workmen's train on the West Suburban Railway which had its terminus in Granville Street was a regular institution. When the new houses were occupied and the gardens began to bear fruit freely, the prejudice gradually died down, and soon they were more keen to come out to Bournville than to remain in town.*

*… The problem of the Christmas rush had not been solved in these early days, for there was no planning office, and as Christmas approached we all went through a most hectic time, my father with his coat off helping to get the orders together.*

*J.S. Edge (14 August 1929)*
*I was interviewed by Mr Richard and Mr George Cadbury, who mentioned that they had received a large number of applicants, and incidentally stated that this was the first time they had advertised for a clerk, as they usually had young men recommended to them, and said that I ought to feel fortunate in being one of three, selected for interview.*

*What impressed me very much was the kindly way in which I was received, and the words of encouragement given.*

*As I walked from the station to the Lodge, I was given a glimpse of the Factory with is beautiful surroundings, and I could hear the singing at the morning service, and it all seemed such a contrast to the Factories in Birmingham.*

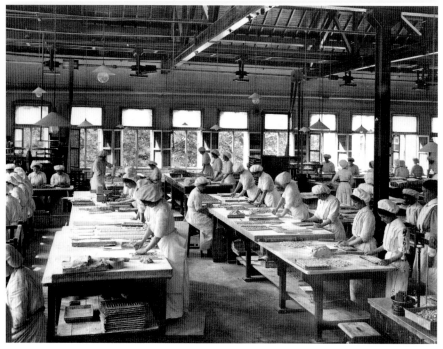

Marzipan cutting in 'C' Block. (*Courtesy of Cadbury Archives and Mondelēz International*)

*The Works at this time were considerable, probably about 1,000 employees, and as I was given the number 23 in the office, being the latest addition, I presume 23 was the sum total of clerks then employed.*

*Everything connected with Bournville seemed to me, as far as possible ideal, and the general tone was of a happy family.*

*One duty which I had, and it may be of interest as a contrast to the present day, was the taking of the letters to the General Post Office Birmingham. I managed to get all the letters and small parcels into an ordinary sized bag.*

*The letters in those days were written in copying ink and a tissue copy taken by means of a press, and the most important letters were signed by Mr Richard Cadbury, and being in the Correspondence Department, I usually got these letters together for signature.*

*Vincent Grimmett (February 1929)*
*My first sight of Bournville was Tuesday morning April the 11th 1882. The Tuesday following the Easter Holiday. When I walked up Bournville Lane from Stirchley Street to seek employment.*

*I entered by the Lodge, then by the Station, and waited outside the entrance to the general office, it being about 10.30 a.m. I am not quite certain, but I think it was J. Figures who came out and told me that there was no one about, and that no hands were wanted. W. Tallis was away with Mr. Barrow Cadbury in the United States of America at the time.*

*I paid another visit to the Works in the afternoon and was more fortunate, as I was asked in and saw both Mr. Richard and Mr. George Cadbury. I spent quite a long time with them, they asked me many questions, I remember what a pleasant talk it was, and in the end I was asked to present myself at the Works the following Thursday morning at 6 a.m. ... I duly arrived at 6 o'clock Thursday morning, and was conducted to the "Cellar" so known as it was a dark room for cooling the chocolate, "the moulding shop in other words," H. Sleath was the foreman, the Creme and Plain chocolate were all moulded in the same room, about 45 hands, men and boys all told.*

*... H. Sleath was a man who had the respect of all those who worked under him, he was always very willing to show any of the boys how to do their work, patient and good tempered.*

*All the chocolate was weighed by hand, and not more than one or two persons did the weighing. After weighing, the chocolate was laid into the moulds, then placed on a Shaker, the Shaker consisted of a loose top table resting on two revolving cogs and when three of these Shakers were at work they made an awful noise.*

*The chocolate after being moulded was carried into the Cellar or cool dark room, laid on stone slabs to set.*

*Bournville seemed to me a very wonderful place, I had never seen the inside of a factory before, I remember I used to go and peep through the Engine Room door, which was glass. All the factory was driven by one engine a "Tangya", and two Galloway Boilers provided the steam. A third Galloway was installed, soon after then a Babcock and Wilcox was placed in another part of the works. W. Earl was the Chief Engineer, he was followed by W. Dunn, I thought W. Earl a clever man to look after such a big engine, and the engine room was always kept beautifully clean.*

*... During the time I worked in the moulding shop work became slack, I asked if I might fill up the time in another department, and I was given work in the Essence Room under T. Hemming, whose brother William was head of the grinding or milling of cocoa ... After a while I did some work at the Stamp, one was considered quite strong if you could do stamping. One had to pull a heavy weight up and then let it drop on to cut [pieces] of cardboard which made tops and bottoms of fancy boxes.*

*Time passed on and I was working in the Mill, under J. Figures (Joe) …
he was so popular and well known, but I remember him as a perfect time-
keeper, a clean well kept healthy looking man.*

*… After some two years … I asked for out-door work, I had an
interview with Mr. George and E. Thackery, and was given a position on
the Advertising Staff, Letter Fixing and Sampling, also at times a little
Exhibition work. I was instructed in Fixing by W. Ennis our first town was
Cambridge after we visited other parts of the Eastern Counties. When I was
allotted a Ground in Yorkshire Leeds as a Centre, after about seven years
of Fixing and Sampling I was promoted to the Travelling Staff in London,
where for the last thirty-two years I have been trying to sell the products of
Bournville.*

*At the present I am selling Chocolate Easter Eggs, and that takes my
thoughts back to Bournville, where I with a few others made the first
Easter Eggs ever made at Bournville sometime about 1885. As my work
at Bournville only occupied about seven years, my inside knowledge is not
intimate after 1889. But I have very clear recollections of Mr. John Cadbury
he used to visit the Works in an open carriage, and his bright healthy
appearance with his silk hat made him a very noticable [sic] person.*

*… The Morning Meetings were a great feature of those days, and leaves
an unfading memory to all those who ever attended them, when all the
employees gathered together each morning in the girls dining room for a
short service, conducted by Mr. Richard or Mr. George, sometimes by both.
The service commenced with a hymn from the collection of Moody and
Sanky, a short reading from the Bible, a few remarks and sometimes a
prayer. It was the best community singing I have ever heard. We became
aquainted [sic] with some of the favourite hymns of Mr. Richard and Mr.
George, "Oh those clanging bells of time," was one of Mr. George's. "Go
bury thy sorrow," Mr. Richard's. Sometimes they would bring a friend to
take the service. It was not difficult to see the great interest on the faces
of the visitors at the sight of 800 to 1,000 workpeople gathered in their
working attire, all dressed in white. I well remember one of such visitors
commencing his remarks with these words, "I take it as no mean privilege
to address such a gathering."*

*Mr. Richard was a very sensitive man and at times emotional, he was
taking the service one morning, and explaining what a wonderful thing
human love was. He had been reading an account of some floods in the
United States. The waters engulfed the villages on its course rising higher
and higher until it reached the bedroom window of a cottage, a Mother
placed her baby on a mattress, as the water rose to where she was, hoping*

*that her child would be saved; this incident left us all with feelings better imagined than described. Mr. Richard when walking around the works would often be seen helping a girl to lift a box, or in some way giving a helping hand, many instances of his little kindnesses are remembered.*

*Mr. George was an out-door man, sport and gardening always had his support.*

Vincent Grimmett had worked for the company for almost forty-seven years when he wrote his letter. At the time he reckoned only Barrow Cadbury could claim a longer service. During his years there, Mr Grimmett saw the workforce rise from 900 to 9,000.

*Tom Hackett (November 1929)*
*The thing that deeply impressed me after coming to Bournville in 1892 was the feeling of paternal interest that the Founders of the Business (both Mr Richard and Mr George Cadbury) took in the whole of their employees.*

*In those days the Works started at 6 a.m. and the quickest way for me to reach work was to walk all the way from Six Ways Smethwick, and I had to leave home at 4.40 a.m. I had only been at work a few days when Mr George came through the Roasting Shop and spoke very kindly to me about my job, and in addition enquired how I was getting to work. He was concerned to know that I had to rise so early, and suggested that I should immediately consider removing into the locality of the factory.*

*A few weeks later Christmas came round, and in those days every employee received an invitation to the Annual Gathering. This Party was a real eye-opener to me and was different from anything previously experienced. The sense of real sympathy and kindly interest in the whole of the employees impressed me exceedingly; particularly when at leaving time we were presented with a bag of fruit and other good things to take home to our wives.*

*… One of the "Red Letter" days for Bournville was the occasion of the Silver Wedding Party given by Mr. & Mrs. Richard Cadbury. The whole of the workpeople and their wives were invited to Uffculme, and on entering the grounds we were turned by our hosts into the Current [sic] and Raspberry Bushes (which contained a magnificent amount of fruit) and told to help ourselves!*

*… It was no unusual thing to see [Mr. Richard] carrying a pile of boxes from one of the Boxing Rooms in order to expedite the despatch [sic] of the Orders from the Warehouse. In doing this he would sometimes lay down his*

*Cap (which he often carried in his hands when in the Works) and some while afterwards he would come back to find it. One of the things for which Mr Richard was admired was the willingness with which he came back to apologise for any hasty remark he may have made, and I always considered this to be one of the graces of his character, and one well worth of imitation.*

*In 1900 the Night Shift was started in the Moulding and Grinding Departments, and has continued for approximately 30 years without a break. In January 1901 I was appointed to be first Night Works Foreman. It was after this time that I came into very intimate touch with Mr George. He took a very keen interest in the welfare of the Night Workers, and was particularly concerned to see that no detrimental influence to their health resulted from night employment. In this connection he was very keen that all these men should have a garden, as he felt that being out in the sun during the day would counteract any detrimental effects otherwise caused.*

*His spirit of consideration for others was shown by the many concessions made to these men; particularly the provision of hot drinks to all workers at each night meal time, the special allowance for night work, and other small amenities which did much to create the right spirit to make for success.*

*… I am certain the prime factor making for the success of Bournville was the spirit of the Founders, and regard it as one of the greatest privileges of my life to have been in any way associated with them.*

*Simon Hall (9 March 1929)*
*I joined the firm in Bridge Street, December 1870, and worked in the Tea and Coffee Department, which was a large Trade. Many customers sent their Raw Coffee which we roasted and returned to them. I enjoyed the trade as I had already served an apprenticeship to the Grocery. Tea tasting with Mr Richard Cadbury appealed to me. The last three months in the year we began work at 6 a.m. A pleasing break occurred around 4 p.m. when cups of tea were handed round, after which we resumed work.*

*… After two years at Bridge Street I started on the road. Previous to this no traveller had represented us in Ireland. My first journey there was January 1873. I had never seen the sea and as we had a rough passage I did not enjoy it. I continued going for a few years and liked it. One thing I sold perhaps sounds peculiar to us in these days. It was Cocoa Shell. There was a demand for this which came packed in chests, I think from Malaga. I acquainted the firm and they decided to pack the Shell in the empty bags in which we received the raw cocoa. This was a help to me as it enabled me to open new accounts.*

*Lily Houghton (no date)*

Weighing Milk Tray. (*Courtesy of Cadbury Archives and Mondelēz International*)

*I can well remember my first morning commencing work at Cadbury Brothers, Bridge Street. I was told to be there at 9.15, and was taken to the Flour Room to work there, and I was delighted to be working amongst the sugar and the flour – just thought it was lovely. All the girls seemed very friendly and happy.*

*… I remember Mr G. Cadbury being very strict concerning any sugar cremes or chocolate being allowed to remain on the floor. To encourage us he gave us a 1/- extra a week if we kept our floors clean, and if we did have sugar or chocolate on the floor he would fine us 6d each.*

*I remember at the following Christmas Party the Firm told us then of their intention to build new works in the country. Of course it was very exciting to hear this, and we were told it would probably be a long holiday the following summer, so we were all encouraged to do our best to prepare for it. All through the spring we talked a lot about going to work in the country and to be where there were fields and lanes, and sometimes we got so excited about it that the forewoman came to us and told us that we should never go to Bournville if we did not behave ourselves, so of course for a time we went very quiet.*

*Then when the summer came the Works closed for eight weeks, and in the following September we came out to Bournville. There was great excitement when we came to the station and we thought the journey to Bournville was lovely, also thought ourselves very important going to work by train.*

*… We youngsters were very anxious to explore the district around and we used to go into the lanes and fields and get blackberries, and at one time some very pretty ivy. Then when winter came we used to go on to Martin Pool and slide there. It was a delightful time for us, and often we have returned too hot to work although the weather was cold.*

*… When we had been at Bournville I think about two years the Firm began to make French chocolates. Mr. G. Cadbury came into Miss Duckett's room and asked for two girls to go into another room and he taught [them] to cover French chocolate. Laura Earl and I were the first to be taught and we were very delighted to see all the new sweets which Frederick (the Frenchman) was making. I do not remember his surname. The first thing we were taught to cover were Avelines. They were I think a Spanish nut roasted in sugar and covered in nut chocolate, and that was the first time we used a fork for covering. Then there were Nougat Dragees, which were very tiny things, Cokernut Flavour, Chocolate Creme Caramels, Pate Duchesse, and other delights. Frederick always gave us just a taste of every new line. Soon our number was increased from two girls to six girls.*

*There was one unfortunate thing happened one day. Frederick was with another man lifting a kettle of boiling sugar from the stove. They spilled some of the sugar on the fire and it blazed up and caught Frederick's arm; he had a very bad burn. The man ran out and brought Mr. Tallis, and he did what we had never seen done before, that was to scrape raw potato and put it on the burn. Then Frederick was taken to hospital, but his arm was bad for some weeks.*

*The French chocolate sold so well that we soon had to have another room. Our number was increased to 18 girls. Then to our dismay a forewoman was appointed and we did not particularly want one. We had gone on very well we thought without one. Louie Alcock was appointed and I can well remember one of the older girls saying to her "Now Louie if you don't behave yourself we shall put you over the bannisters". In a short time the trade increased so that the present room was not large enough and we removed to a very nice large room where we could have the packers as well as the makers. The room was what is now the Plain Chocolate Room. I well remember the first Christmas Party which Frederick attended. He made a very beautiful thing of crystalized fruits … We thought he was the cleverest man in the world.*

*Trade increased in all branches; then came the difficulty of working overtime. There were no early trains in those days because it was only a single line, so we either had to get lodgings in the district or walk from Birmingham. Some of the girls got lodgings and some walked from Birmingham and district. Mr. R. Cadbury and Mr. G. Cadbury thought of a plan which helped the girls who lived a distance away. They fixed up the Men's Dining Room as a sleeping room and it accommodated quite a number of girls – I believe over twenty. They used to go home after work and return by the 9.30 train, so that helped for the time.*

*I remember when we first came to Bournville that what is now the Bournville Cocoa Dept. was the old stock room where we used to have boxes and cocoa weighers and stock, and an office for the Head Forewoman, and one part partitioned off for a dining room.*

*E.J. Organ (15 March 1929)*
*For several years prior to my coming to Bournville, I was at a merchants' office in Birmingham – Rabone Bros. & Co. – at the corner of Bridge Street and Broad Street. They were the landlords to Cadbury Bros. Ltd. when the Works were in Bridge Street. My first connection with the latter Firm was when we used to ship out consignments of Cadbury's chocolates to South America. I shall always remember the interest which the indents for Bournville created; they were so different from our usual orders for buckets, galvanized iron, hatchets, hoes, bedsteads and saddlery. We gathered round, repeating to each other the names of the famous lines of those days – "Créme Duchesse", "Pistâche de Montelimart", "Jordan Almond Pralines", etc. These names affected our imagination: we had no actual knowledge of them, our acquaintance with Cadbury being confined to Cocoa Essence and Cream Cake.*

*A year or two before I left Rabones I had to write a letter to Bournville asking if the nephew and niece of Mr. George Dixon M.P., who at that time was still an outstanding figure in Birmingham politics and education, might be allowed to go over the Works at Bournville. The answer received was in the negative. I mention this as illustrating the complete change in our methods. Yesterday, some 600 people trailed up the road to come over the Works.*

*I started at Bournville in the August of 1896, just in time to assist in the intensive shipping and invoicing campaign which lasted wellnigh until Christmas. Mr. Dennis was head of the Export Department at that time, and Mr. Brown succeeded him shortly after.*

*... Bournville Lane was really a lane then, and the nests in the hedge and the blackbirds in the tree on the opposite side of the road, were a great delight to us every spring. Was it a blackbird or a thrush? I have forgotten in so many years, but I wrote a poem about it at the time, which was put in the Bournville Magazine. Coming as I did from the centre of Birmingham, it can readily be imagined how all these things delighted me.*

*In those days, Mr. Edward Cadbury, accompanied by Harry Gear, used to come down first thing in the morning to go through the letters. The office was small, so one could not but overhear their comments. Looking back on those days, I can see Mr. Edward's quiet intensive absorption of all export matters, which laid the ground for that easy mastery of this aspect of the business which he showed in later years.*

*We used to write the invoices out by hand, and as a carbon copy had to go to the customer abroad, they had to be written decently and legibly. A year or two later Mr. Edward came down with Mr. H.E. Johnson and asked to see one of the invoices. I remember that they complimented me on the neatness of mine, and asked what I thought of the idea of having them typed. I said that I thought it would not be a success, owing to the difficulty of alignment. Mr. Edward was evidently right and I was wrong. Shortly afterwards, Clara Davis came down and taught us how to type, and the new method succeeded very well.*

*At that time we had a depot in Paris, which fact was mentioned on the heading of our letter paper. In 1897, Mr. Johnson came down to the Export Office and asked me if I would like to go to Paris for a fortnight. For three years in succession I went over in the hottest months of the year to take the place of our representative – Mr. Bennett – while he took his holiday. Our depot was in the Faubourg St. Honoré – the famous street which for centuries had been the centre of the most poignant and most dramatic happenings of French history. The depot was quite near to the Madeleine and the Place de la Concorde, and almost exactly opposite was the great iron gate of the courtyard of the Elysée Palais, where almost daily I used to see the President of the French Republic arriving in state.*

*... Our trade in Paris was a very limited one. Owing to the very heavy customs tariff and to its curious incidence, we could only sell a few lines. But for these we had our regular and staunch customers, most of them belonging to the French aristocracy or decaying nobility.*

S. Powney (no date)

*I started my duties at Bridge Street during the month of November 1876. So far as my memory serves me, I believe the total male staff was about 70. Even in those days the Factory was somewhat self-contained, as Box and Case Makers were employed, also a Carpenter, and a Saw Mill was in existence.*

*I was drafted into the Chocolate Mill, which at that time was small, the staff consisting of four others and myself. In the same shop the Cocoa was also made, and at that time a number of brands were made including "Essence", "Pearl Cocoa", Homepathic [sic] Cocoa" "Iceland Moss Cocoa", and "Rock Chocolate".*

*The process of Chocolate making was to partly grind, then mould in pans holding about 28-lbs. and carried into the yard, stacked in racks to cool, then turned out and put into stock. This method was believed to mature the chocolate and bring out the aroma. When finishing for covering or moulding, it was necessary to carry the blocks into a stove to be warmed through. From here, the whole staff – 5 in number – would troop from the stove across the factory, chain fashion, carrying the 4 pans of chocolate – about 84-lbs. in each – for mixing and grinding. The usual day's output would consist of three such batches, i.e. 4 pans before breakfast, morning, and afternoon, or roughly 9 to 10-cwt.*

*… During the closing period at Bridge Street, I was engaged loading up machinery, etc. into wagons and "Sparreys's Boat" until the morning I was sent to Bournville to again commence Chocolate making in the new factory.*

*… The Firm always had an interest in Sport and Recreation, and although nothing of an organised nature was undertaken at Bridge Street, when work permitted H. Sleath was sent in charge of the boys to Cannon Hill Park, to play cricket, football, etc. so that Recreation Grounds, Swimming Baths, etc., as we know them today – together with the huge Factory – had their birth place in Bridge Street.*

*A.J. Turner (no date)*
*I came to Bournville in June 1891 and was engaged by the late Mr. George Cadbury who interviewed all applicants for employment on the mens side, the late Mr. Richard Cadbury performing the same duty on the Girls side. I was instructed to report myself to Mr. W. Tallis, who was then Works Foreman, and to commence work the next morning at 6 a.m. I was informed that biscuits and cocoa would be provided free of charge, in the Mens Dining Room, before 6 o'clock for all who cared to partake of them. I*

*had to walk from Kings Norton and this refreshment was much appreciated and I rarely failed to take advantage of it.*

*On reporting myself to Mr. W. Tallis I was sent to work in Moulding 1. This was the first moulding room erected. The main lines were Mexican, Vanilla, and D. Chocolate. 6d. Chocolate was transferred to a separate room adjoining the Chocolate Mill, under the charge of the late Harry Sleath. At this period all the Plain Chocolate was moulded entirely by hand, which required a great deal of labour, the majority of which was youths and boys. The only machines used in moulding chocolate in those days were one melangeur for mixing Mexican, one small compressor for the same line, several shakers and a cooler. The chocolate was cooled in a four level cooler connected up with outside air. The large blocks of chocolate were left to cool on a raised slab in the cellar without any artificial aid. The moulds were heated by gas jets enclosed in an iron oven with a marble slab on top. The latter was used for heating up chocolate that had become too cold for moulding. The moulds, due to the method of filling, required frequent washing. When this was found necessary, the Shop stopped work and all the labour was put on cleaning and polishing moulds by hand.*

*... At least once a week all men, boys, and girls met in the large Dining Room for Morning Meeting. After a hymn was sung we listened to a short address either by Mr. George or Mr. Richard Cadbury.*

*... Although there was adequate Dining accommodation many of us boys, Summer and Winter, had our breakfast and dinner in the fields adjoining the stream which reached from the Railway bank up to the Cage Walk near No.5. Moulding. A good proportion of this land was planted with fruit trees and the remainder was used as playing fields. Here we played Football and cricket in season. Mr. George Cadbury very frequently visiting the playing fields and had a kindly word to say to all with whom he came in contact.*

*... Mr. George and Mr. Richard visited the workrooms very often. I remember Mr. Richard had a strong aversion to the Cocoa Moth if he saw one flying about in a workroom, he would not leave until it was destroyed, very frequently showing an example by destroying the pest himself.*

### S.A. Mann (no date)

*My memory does not carry me far into the doings of Bridge Street, Birmingham, but one thing stands out very plain, that is the first morning I went into the office of Cadbury Bros. Well do I remember Mr. George Cadbury and his cheerful Good morning which soon put aside all my fears,*

*for it must be remembered I was but a girl of 13 years and only <u>very</u> small for my age, which I was soon to remember. I can always see Mr. George Cadbury when he sent for the forewoman of the Covering Department. When she came in she looked at me, and the first words she said were, 'Mr. George she is so little'. But Mr. George was to have his way, and said she was to try me, but she still thought I was too little. However, all came right in the end, and I was on trial which lasted 42½ years, which would have been longer had my health not have failed.*

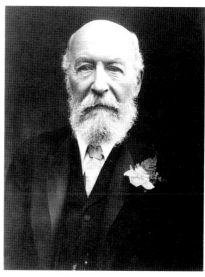

George Cadbury. (*Courtesy of Cadbury Archives and Mondelēz International*)

*I will now try to explain what a Covering Department was 60 years ago – 4 long tables with a steam pipe along the centre, over them a covering of iron to keep the chocolate warm; on the top of this raised platform were small irons, 2 girls to one iron, one each side of the table. Each piece of chocolate was covered separately, and each piece taken out of the iron with a bone stick (very much like a toothbrush only the point was ground to rather a sharp edge), and put on a paper; then when the paper was full put away to dry.*

*I remember Mr. George Cadbury when he wished me Good-bye said: "At eventide it shall be light", which I have proved to be true. He has gone to his well-earned rest and to hear the Master say: "Well done, good and faithful servant."*

*Mrs J. Clarke (Florence Livingstone) (no date)*
*I well remember at Bridge Street six fancy box makers and a little girl to wait on them, also six creme coverers and a little girl to wait on them. Then there were four of us girls to box chocolate sticks, and we used to fill an 8 pound box for 3¼d. We of course worked hard as we were piece work. I well remember my first week's wages. It was 5/10, and Mr George gave me 1/6 to that, so of course I thought I was very rich for a little girl just leaving school. However, they were very happy days, I can assure you.*

*We used to have prayer meetings in the large workroom, and at that time we used to cook our own breakfasts, also our dinners, on a large stove.*

*But I must tell you Mary Brown took a great interest in us as we were all young, – like our dear old masters, kindness itself. I cannot just remember how many there were of us altogether, but I should say about <u>50</u> when we were very busy. We would have to go at 6 in the morning, and there was always a cup of coffee and a bun.*

*Then our trade was getting too big for our Bridge Street factory, so our dear masters began to think out the best to do. Then of course in time we landed at Bournville, which was a big change from Bridge Street and a great improvement. I might say there was no early train of course for a long time, so when we got busy towards Xmas we who lived at Birmingham (I was one of them) walked through the snow. They were winters then, not like the present ones. One morning I was walking along the Bristol Road and could not hear any of the girls before me neither behind me, so of course I thought I was late. I think I must have liked my work, for when I got to the Check Office and knocked the door, the watchman opened it and said, Whatever brings you here this soon. I said, Why, what time is it then? He said, A quarter to 5 – and it should have been that to six. But they were very happy days, and those who <u>knew</u> our dear masters could never forget them. (I am quite sure Cadbury's always seems on my brain.) Then the masters got 12 beds, had half of the men's dining room and had them put up there at night. We used to sit round the fire doing fancy work and singing, and Mr. George used to call and see us. He never passed the Works, he would always come in and sing with us. I well remember he would ask us to sing, "I have read of that beautiful city."*

*Chapter 18*

# Takeovers, Mergers, the Future

The firm of Cadbury started out as very much a one-man business. Early on in its history, that man was joined by his brother, then by his sons and then those sons' families. The workers became an extended family too, and were treated as such by the owners and, later, directors.

Even when it became a limited company, the family was still represented, both on the board and within the workforce. Cadbury has seen a lot of change in the past 120 years, since John Cadbury died. There have been quiet mergers, and there have been well publicised mergers, such as those below. The biggest changes have perhaps happened in the last fifty years. In the past ten years, however, since 2009, these changes have been quite tense.

## Fry's

In January 1919, Cadbury Brothers Limited merged with Messrs J.S. Fry and Sons Limited. (See also Chapter 16.) In May 1919, a holding company was formed, the British Cocoa and Chocolate Company Ltd, to hold the ordinary shares for Cadbury Brothers and the A and B deferred ordinary shares for J.S. Fry and Sons. This new holding company then, in turn, issued its own shares in proportion to those it had taken over – with the agreement of all parties. This meant that while both companies retained their own individual identities, a community of interest was created and a joint board established, consisting of directors from both companies.

Cadbury and Fry joined forces with James Pascall, the confectionery company, in 1921 to build the Claremont factory in Australia, and they became Cadbury Fry Pascall over there. (Also see Chapter 7.) Pascall Murray, another sweet manufacturer that was created following the merger of Murray with Pascall, was acquired by the firm in 1964.

Early Fry's advert, c1900. (*Courtesy of Cadbury Archives and Mondelēz International*)

## Schweppes

In 1969, the biggest merger thus far was undoubtedly when the Cadbury Group merged with Schweppes. Jacob Schweppe of Switzerland first arrived in England in 1794, but it appears he was in business before then. By 1880, his firm was the first to achieve a reputation for soft drinks of a superior nature.

The company were keen to remind everyone that it was a merger and not a takeover:

> *MR. ADRIAN CADBURY stressed the equality basis of the Cadbury-Schweppes merger when he gave details to a meeting of management council and union representatives, and delegates from other factories. He also gave an assurance there would be no reduction in working conditions resulting from the merger.*
>
> *"This is not a case of one company absorbing another," he declared. "It is a fifty-fifty agreement between two large companies who have decided it would be in their best interests to come together in order to be more successful, to grow faster, and be more profitable."*
>
> *Bournville Reporter*, February 1969

(*Courtesy of Cadbury Archives and Mondelēz International*)

At its peak, the new company, Cadbury Schweppes plc, employed 16,000 people in the UK alone, and 35,600 worldwide. Typhoo had already joined Schweppes in the late 1960s, but in January 1973:

> *FOODS AND TYPHOO are to integrate next month to form a new and powerful Tea and Foods Group capable of presenting a stronger front to the grocer. The new group, with a turnover of £70 million a year, and a combined labour force of 7000 comes into being on January 22 – the day that John Beasley, deputy chairman and marketing director of Cadbury confectionery becomes chairman of the new group.*
>
> Foods Group News, December 1972

By May 1983, the company of Schweppes was preparing for its 200th birthday. *Tea & Food News* reported:

> *TWO HUNDRED YEARS ago Jacob Schweppe founded the soft drinks industry when, in 1783, he began selling his carbonated drinks commercially. And 1983 is being celebrated around the world as Bicentenary Year by Schweppes companies and franchise bottlers.*

Cadbury's selection box, c2015. (© *urbanbuzz/shutterstock.com*)

*… Mr [Basil] Collins explained that German-born Jacob Schweppe was a jeweller and craftsman in precious metal who was committed to fine and precise workmanship.*

*He applied the same standards when he devised apparatus for aerating water, and, went on Mr Collins, the range of drinks subsequently sold under his name followed his requirements of unique standards of excellence. This hallmark of Schweppes products led to their international reputation.*

*"It is a paradox," he said, "that a German-born, naturalised Swiss, should come to England to create products which would gain international regard as being essentially British."*

Following this merger, Cadbury Fry Pascall became Cadbury Schweppes (Australia) Ltd. They subsequently acquired the French business of Chocolat Poulain in 1987 and the Spanish company of Leading Spanish Confectionery in 1989. Also in 1989, Trebor & Bassett was acquired.

### Kraft

In 2009, the American food company Kraft Foods launched a hostile takeover bid that was initially resisted by the board at Cadbury

Schweppes. Kraft's intention, as it turned out, was to be a large enough organisation to split itself into two: a grocery business and a snack business. They needed the Cadbury element in order to enter emerging markets in places such as India.

The problem was, Cadbury was not for sale and the company resisted the takeover. Unfortunately, the American company won their bid and they did indeed split the company in two. Despite promising that British factories would be kept open, Kraft closed the Somerdale factory in Bristol (formerly owned by Fry's) in 2011. In 2015, the 6m-high Cadbury sign was removed as the site was prepared for residential development.

## Mondelēz International

Following its successful takeover Kraft named the spin-off company Mondelēz International in 2012. In 2016, Mondelēz came under fire for not keeping its promise to continue making chocolate at Bournville. Instead, it moved some of its manufacturing to Poland. But following a £75 million investment in the Birmingham plant, it looks as though they have made a new promise to return Cadbury's Dairy Milk to the UK. Although, according to an article in the *Daily Telegraph* in April 2017: 'The money will be spent on new machinery to increase production while reducing the size of its workforce.'

## The Future?

In January 2018, a news story appeared in the *Birmingham Post & Mail* introducing James Cadbury, who has been making organic chocolate in London since 2016. 'Meet Cadbury descendant planning to open chocolate factory in Birmingham' shouted the headline. 'James Cadbury hopes to carry on the legacy of his ancestors by moving his high-end chocolate company out of London to his home city,' it continued.

James Cadbury is the great-great-great grandson of John Cadbury. By the time James was born, in 1985, his family were no longer as involved with the business as they had been in the beginning. In 2016, James opened his own company in London. Inspired by his forebears and building on their ethics, the company makes gluten-free chocolate without using refined sugars, palm oil, or any 'other nasties'. Instead, Love Cocoa makes luxury organic chocolate bars with flavours such as avocado, honeycomb, sea salt and crushed coffee. They're also partnered with the Rainforest Foundation.

Unfortunately the company isn't in a position to move yet as they need to increase the number of products produced each month. It's in the business plan, though, and James Cadbury is apparently considering opening a micro factory in the historical Jewellery Quarter or Digbeth in Birmingham.

Chocolate, the way his ancestors intended, might be coming home …

Cadbury Heroes, c2016. (© *Craig Russell/shutterstock.com*)

# Author's Note

The Cadbury family were Quakers with a good, solid social conscience. Quakers are pacifists, but this did not stop the Cadburys helping out during the Boer War, the First World War and the Second World War. They did not take their conscientious objections to the extreme, as did others in the name of the religion. Instead, they actively encouraged their non-Quaker employees to sign-up and do their duty, promising to keep jobs open for those who came back. And they kept that promise.

As an employer, Cadburys were probably a model company to work for. They believed that a healthy, happy workforce resulted in a healthy, happy business, with loyal staff who wanted to work there and who felt they had a vested interest in making the organisation a success. The Cadburys wanted to build a pleasant factory in pleasant surroundings, where it would be a pleasure to work, and where workers wanted to come to work. And they did that. They wanted their workers to live in pleasant homes set in pleasant gardens that were a pleasure to live in. And, to a certain extent, they did that too. They wanted their workforce to be educated, and so they delivered that education in many ways by providing school buildings and organising school camps, and by allowing workers time off to go and do that learning. The Cadburys didn't mind that if a worker discovered an interest or a vocation outside of the company, he or she might want to go and pursue that path. In fact, they actively encouraged that too.

The Cadburys wanted their workforce to be fit and healthy and able to swim. They provided playing fields, fully equipped gymnasiums and even swimming pools – inside and outdoor – and they made it a condition of employment that every worker should be able to swim or learn to swim. And then those employees who wanted to pass on that skill would go outside of the company and teach others to swim.

Apart from all of this, there was the financial side of things too, for both the company and the employee. The company needed to make money and survive, and that is what they did. When other companies floundered, closed down and disappeared without a trace, the firm of

Cadbury adapted, diversified and survived. But at the same time they paid what was considered to be a decent wage, they contributed to pension funds and encouraged the workers to save, and they set-up various welfare and benevolent funds. They made charitable donations and financial gifts. They gave back to the community and they built a community.

Some may believe that the Cadbury family were 'patriarchal' in the way they treated their employees, calling them 'do-gooders' or bigoted. After all, they 'forced' their workers to attend educational classes and learn to swim. They made some things compulsory, or a condition of employment. They refused to employ married women for a very long time, and obliged young women to choose between marriage or a career. And for many years they imposed morning prayers onto the workforce, whether they wanted them or not. Every day.

Others may class the Cadburys as simply 'paternalistic', wanting the best for their staff, even if that meant losing staff. They believed that certain men of the time were more than happy to idle away their lives and get drunk, living off the wages their already hardworking wives earned. And they believed that women, at that time, should be looking after their homes and families instead of working in a factory. Perhaps those who think this belief is quite high-handed should replace the word 'wife' with the words 'spouse' or 'partner'. But this was not the way of the world at that time.

The Cadburys were very forward-thinking in a lot of ways. They were pioneers. Perhaps, had general beliefs been different too in those days, then maybe they would have been less gender-specific, perhaps they would have reached the equality and equal opportunities first. And, in fact, the company did catch up long after the family handed over control of the firm to first a private and then a public board.

The factory in a garden was unheard of and probably looked on at the time with mild amusement. It is perhaps ironic that Bournville is now surrounded by that urban sprawl the Cadburys were so keen to get away from. The districts of Stirchley and Cotteridge are built-up and traffic can be a nightmare. I wonder what George Cadbury would think if he could see his beloved garden city today.

When I began this journey into the history of Cadbury, I didn't really know what I was letting myself in for. I thought I would be lucky to scratch together sufficient material for a slim volume. But scratch is what I did – I simply scratched at the surface of this deep and profound

organisation. I have not had the time, nor do I have the space, to go into the many different processes of chocolate-making across the decades. I haven't looked at any of the business financials, the bought ledger, the sales ledger, how much each product cost the company and how much they retailed for. I've not touched on wages or dividends. I've ignored more than a century of transport and I didn't cover the royal connections. I've only briefly mentioned something about the mergers, the Quakers and the actual history of chocolate. These are all separate stories in their own right – even 'Cadbury at war' could fill an entire volume.

Instead, I have covered some of the social impact this company has had since its inception, both on the chocolate and cocoa business in general and on the community at large, within and without the firm of Cadbury. I've looked at the people who set the foundations of a company many of us know and love today. I have made a very brief inclusion of the Cadburys and the slave trade, and I have considered the Cadburys' involvement in the garden city movement of the early twentieth century.

There is yet more to learn still of the company today, for it continues to operate and it still has a presence in Bournville in Birmingham as well as all over the world.

# An Early Example of John Cadbury's Philanthropy and his Concern

## Letter to the Duke of Sutherland, from John Cadbury

In reply to thy favour of the 30th ulto., I beg respectfully to state that the progress of the use of machines for sweeping chimnies [sic] in this town has been for the last six years gradually on the increase. One man was first supplied with a machine, and soon found full occupation; a second was then introduced and met with similar results; and about two years ago a third also began and finds likewise pretty full employ— besides which the old sweeps who keep the climbing boys have found it necessary to obtain machines also to satisfy some of the employers who were determined no longer to use children—but I regret to say that out of this circumstance much prejudices against the machine has been raised, owing to these masters of the boys having very improperly worked the machine and said and done all they could to prejudice the minds of servants against them. I rejoice to say nevertheless that our cause is still progressing onwards. The public buildings in the Town, which are not very numerous, are generally swept with a machine— such, for instance, as the Hospital, Asylum, Deaf and Dumb Asylum, Oscott College, Banks, principal Hotels.

I enclose the testimony of a few respectable families, who for many years encouraged the use of the machine, and if necessary abundance more might be added. Thou art probably aware that a petition to the House of Commons in support of the Bill went from this Town most respectably signed, and I regret a similar one, which might as easily have been obtained, was not prepared to be sent to the House of Lords. The testimony of the only Fire Office establishment in this Town I send herewith—the other offices are merely agents from London houses.

I believe I may with safety say that there is scarcely one chimney in many hundreds—indeed I question if there would be found more than one in a thousand—wherein any serious obstruction presents to the free use of the machine.

I am not aware that I can make much further addition unless it be to assure thee that my mind has been deeply interested for many years on the ground of humanity alone, in endeavouring to introduce the use of the machine and to remove the difficulties opposed to it—for this purpose I am free to say to thee that I have often attended in person to superintend the application of the machine.

I shall be most happy to attend with promptitude to any further enquiry thou mayest think it right to obtain from this quarter—and under a feeling of much personal obligation to thee for thy exertion in this cause of humanity allow me to subscribe myself most respectfully.

<div align="center">

JOHN CADBURY

Tea Dealer

</div>

<div align="right">

*(Life of George Cadbury)*

</div>

# 'Visit to a Chocolate Manufactory'

BIRMINGHAM, so says *The Times* is famous for 'lacquered shams;' and any one who has sojourned for awhile in the huge, smoky toy-shop will add—for not a few genuine realities! To walk from factory to factory, from workshop to workshop, and view the extraordinary mechanical contrivances, the ingenious adaptations of means to ends, to say nothing of the eager spirit of application manifested by the busy population, produces an impression on the mind of no common character. Besides which, the town itself, so ill-arranged and ugly, is a spectacle; and in the people that inhabit the dismal streets, the visitor may find studies in morality as well as manufactures.

We have something to say about one of the realities alluded to above—not the making of pens, or tea-pots, or papier-maché; but of something in which breakfasts are implicated all over the kingdom—the making of cocoa and chocolate as carried on by Messrs Cadbury Brothers. These gentlemen having kindly invited us to a sight of their establishment, we took the opportunity of witnessing their processes for converting raw produce into an acceptable article of diet, aided by the ample explanations of one of the partners. Such a manufacture seems out of place among bronze and brass and hardware, but the factory stands away from the fuliginous quarter, on the verge of Edgbaston—that Belgravia of Birmingham – where sunshine and blue sky are not perpetually hidden by smoke. What we saw there is worth the telling, as we hope to shew [*sic*].

Here, however, we must say a few words concerning the raw material. It appears that the Spaniards were the first Europeans who tasted chocolate; it was part of their spoil in the conquest of Mexico. Bernardo de Castile, who accompanied Cortez, describing one of Montezuma's banquets, says: 'They brought in among the dishes above fifty great jars made of *good cacoa*, with its froth, and drank it, the women serving them with a great deal of respect;' and similar jars were served to the guards and attendants 'to the number of two thousand at least.' The Spaniards enjoyed the rare beverage, and with a slight transformation

of the native Mexican term *Chacoc-atl*, they introduced chocolate, as they named it, into Spain, monopolising the article for a time, and it was only by slow degrees that the knowledge of it spread into other parts of Europe. Gage, an old traveller who had visited the tropics, writing in 1630, remarks: 'Our English and Hollanders make little use of it, when they take a prize at sea, as not knowing the secret virtue and quality of it for the good of the stomach.' In the reign of Charles II., it was so much esteemed in England that Dr Stubbe published a book, entitled *The Indian Nectar, or a Discourse concerning Chocolate, &c.*, giving a history of the article, and many curious notions representing its 'secret virtues;' and recommending his readers to buy it of one Mortimer, 'an honest, though poor man,' who lived in East Smithfield, and sold the best kind at 6s. 6d. the pound, and commoner sorts for about half that price. Of course, none but the wealthy could drink it; indeed, we find writers of the past century alluding to it as an aristocratic beverage.

Linnæus was so fond of chocolate, that he called it *food for the gods* in the distinguishing name which he gave to the tree that produces it—*Theobroma cacao*. The tree is a native of tropical America, but is now largely cultivated in other parts of the world. It grows from twelve to sixteen feet high, with evergreen leaves, and fruit of a deep orange colour when ripe, resembling a cucumber in shape, and containing from ten to thirty seeds. These seeds are the cacao-nuts or cocoa-nibs of commerce; in the trade, they are commonly spoken of as cocoa-nuts. The best kind are bought from Trinidad; and such has been the effect of lowering the duty, which was formerly 4s. per pound, to one penny, the present charge, that the quantity imported in the year ending January 5, 1852, amounted to 6,773,960 pounds. Among the colonial produce shewn *[sic]* in the Great Exhibition, cocoa-nuts held a conspicuous place; and it ought to be understood, that from such as these cocoa and chocolate are made—both from the same article.

To return to the factory. We first saw a storehouse filled with bags of nuts or nibs, two hundredweight in each, the only kinds used on the premises being those from Trinidad and Grenada. In an adjoining room, imbedded *[sic]* in a huge mass of brickwork, are four cylindrical ovens rotating slowly over a coke-fire, each containing a hundredweight of nuts, which were undergoing a comfortable process of roasting, as evidenced by an agreeable odour thrown off, and a loss of 10 per cent. in weight at the close of the operation, which lasts half an hour. Thus, in a day of ten hours, the four ovens will roast two tons of nuts, the

prime mover being a twenty-horse steam-engine. The sight was one that would have gladdened Count Rumford's heart, for the cylinders and their fittings comprised all the economical principles of his roaster— certainty of effect without waste of fuel.

The next step is to crack or break the nuts in what is called the 'kibbling-mill.' The roasting has made them quite crisp, and with a few turns of the whizzing apparatus, they are divested of their husk, which is driven into a bin by a ceaseless blast from a furious fan; while the kernels, broken into small pieces, fall, perfectly clean, into a separate compartment, where their granulated form and rich glossy colour give them a very tempting appearance. The husk is repacked in the empty bags, and exported to Ireland, where it is sold at a low price to the humbler classes, who extract from it a beverage which has all the flavour of cocoa, if not all its virtues.

Thus prepared, the mass of broken nut is ready for more intimate treatment, which is carried on in a large room where shafts, wheels, and straps keep a number of strange-looking machines in busy movement. Some of these are double-cylinders, highly heated by a flow of steam between the inner and outer cases—an arrangement by which any degree of temperature can be produced in the interior. Inside of each works an armed iron-breaker, which, as soon as a quantity of the cracked nuts is introduced, begins to rotate, and, by the combined influence of heat and pressure, liberates the oil of the cocoa bean, and soon reduces the mass to a liquid which flows, 'thick and slab,' into a pan placed to receive it, leisurely as a stream of half-frozen treacle. In this state it is ready for grinding between the millstones, to which it is successively transferred, being poured into 'hoppers,' which, like the cylinders, are heated by steam. The cocoa flows rapidly from the stones in a fluid smooth as oil; but it is the best kinds only that are favoured with the most trituration, the commoner sorts being more summarily dismissed. At the time of our visit, a pair of new stones were in course of erection, which of themselves will turn off a ton of chocolate per day.

The process, so far, is that employed for all kinds of cocoa and chocolate, the nuts, as before stated, being the basis of all: the variety depends on subsequent admixture, the best kinds being, of course, the purest and most delicately flavoured. Up to this point, we have the cocoa in its native condition, merely altered in form; but now it has come to the stage of sophistication.

A given portion of the cocoa liquid is poured into a pan, and weighed with other ingredients, which consist, in the main, of arrow-root, sago,

and refined sugar—the latter reduced to an impalpable powder—besides the flavouring substances. The quality depends entirely on the proportions of these ingredients, and on their unexceptionable character. The unpractised eye may not detect any difference between a cake of genuine chocolate, and another two-thirds composed of red earth and roasted beans. We have seen documentary evidence laid before the Board of Excise, shewing *[sic]* that a certain manufacturer of cocoa used every week a ton of a species of umber for purposes of adulteration; and recent investigations have shewn *[sic]* that such practices are only are only two frequent. No wonder that muddy and insoluble grounds are found at the bottom of breakfast cups! No one pretends that manufactured chocolate or cocoa is unmixed; but it is a satisfaction to know, that the admixture is not only of good quality, but nutritious.

The necessary quantities having been weighed and duly stirred together with a large wooden spoon, are poured into a mould nearly three feet in length, about nine inches wide, and from three to four inches deep; and in from four to five hours the mass is sufficiently solid to bear removal, when it is turned out as a large cake or block, which might very well pass for a huge sun-baked brick from Nineveh. In this way any number of cakes may be produced, those made on one day being finally worked up on the next, by which time they have become somewhat more hardened.

In this final process, the cakes are laid one at a time in what resembles a chaff-cutting machine, except, instead of the ordinary broad knife wielded by grooms, that a wheel, armed with four sharp blades, whirls round at the open end. The block of cocoa, held by machinery, advances with a slow continuous motion, until it touches the blades on the wheel, when immediately a cloud of most delicate slices or shavings is thrown off, as rapidly as sparks from a knife-grinder's wheel. Cake after cake is thus comminuted, at the rate of a ton per day from a single machine. The shavings are collected as fast as they fall, and passed through a sieve, which reduces them to that coarse powdery form so well known to all consumers of soluble chocolate. It is then put into barrels, and despatched without delay to the packing-room by means of a railway.

That there is something in a name, is as true of cocoa and chocolate as of other things, and the difference of name implies, in most instances, a difference of manufacture. Hence there is a variety of

processes going on within the building, the results of which are shewn *[sic]* in 'Cocoa Paste,' 'Rock Cocoa,' 'Eating Vanilla Chocolate,' 'Penny Chocolate,' 'French Bonbons,' 'Flaked Cocoa,' 'Homœopathic,' &c. So numerous are the sorts, that a purchaser is as much puzzled in his choice as an untravelled Cockney with a Parisian bill of fare. The making of the flaked cocoa is peculiarly interesting, and is, we were informed, peculiar to this establishment. To see how the amorphous mass comes from the mill in long curling ribbons, uniform in thickness and texture, is a sight that provokes astonishment, as much by the rapidity of the operation as by the ease with which it appears to be accomplished, but which has only been arrived at by a persevering circumvention of vexatious difficulties.

But however interesting the results, one grows tired at length of the noise and clatter of machinery; and it was with a feeling of relief that we mounted to the packing-room, where all was so light, cheerful, and orderly, as to prove that the good management everywhere perceptible had here put on its pleasantest expression. The most perfect cleanliness prevails. The half-score or more of girls, who work under the superintendence of a forewoman, are all dressed in clean Holland pinafores—an industrial uniform. All were packing as busily as hands could work: one weighed the cocoa; a second placed the paper in the mould, and turned the cocoa into it; a third compressed the contents by means of a machine-moved plunger; while a fourth released the packet, pasted down the loose ends, and laid it aside. This party, by their combined operations, weigh and pack a hundredweight per hour. Some were wrapping the 'homœopathic' in bright envelopes of tinfoil; others boxing the 'bonbons;' others coating the 'roll' with its distinctive paper; while others helped the forewoman to count and sort the orders—all performing their duties with that celerity which can only be attained by long practice. Finally, the respective orders are packed away in boxes of various sizes, from fourteen pounds to a hundredweight; and to give full effect to the system of cleanliness, none but new boxes are used, so that not the slightest ground is afforded for even a suspicion of uncleanliness.

In these professedly enlightened days, commercial progress cannot well be considered apart from moral progress; we want to know not only how work is done but who and what they are who do it. Are they benefited by the 'mighty developments of commercial enterprise?' We may therefore very properly say a few words respecting the *employés [sic]* in the cocoa-factory. No girl is employed who is not of known good

moral character. Some at first are found to be good rather passively than actively, but they have example daily before their eyes, and a spirit of emulation gradually develops their better qualities. Their hours of work are from nine A.M. to seven P.M., with an hour off for dinner—tea is supplied to them on the premises. Their earnings range from 5s. to 9s. per week. Once a week, during the summer season, they have a half-holiday for a little excursion to the country, and twice a week they leave work for evening school an hour before the usual time. With few exceptions, these elevating influences are found to tell favourable on their conduct; and besides the direct benefit to themselves, we may be permitted to take into the account, the benefit to the homes and families to which the girls belong. Accustomed to order and cleanliness through the day, they can hardly fail to carry these virtues with them to their dwellings. The men employed exhibit the good effects of proper management not less than the girls. Some have acquired a steady habit of saving, and with nearly all, from the mere force of example, teetotalism is the rule. Instances of misconduct are rare, and when reproof is called for, it is administered by an appeal to the better feelings in preference to angry demonstration. Factories conducted on such a system must be at once schools of morality and industry.

There is one more point which we feel bound to notice in closing our article. While going about the premises, we were asked to look to the top of the tall engine-chimney, where, to our surprise, none but the faintest whiff of vapour was visible. 'There is no need,' said our conductor, 'that any chimney in Birmingham should smoke more than that. I have told the people so over and over again, but to little use, for they will persist in wasting fuel, and blackening the atmosphere. This is Beddington's patent, and you shall see the effect of it.' The fireman was then told to shut off the apparatus from the flue; immediately a dense black smoke poured from the chimney-top, and when at the murkiest, the order was given: 'Now turn on again.' In five seconds, the smoke had vanished, and the almost imperceptible vapour alone remained. Thus, of the coal consumed daily, not a particle is wasted, and a considerable portion of the atmosphere is saved from deterioration. So perfect an example of what can be done towards the abatement of a nuisance, made us wish to be autocrat for a week—our reign should be signalised by the extinction of smoke!

(*Chambers's Edinburgh Journal,* October 1852)

# 'The Production of Cocoa. Messrs. Cadbury's Action for Libel.'

At Birmingham Assizes on Monday (before Mr. Justice Pickford) an action to recover damages for alleged libel was brought by Messrs. Cadbury Bros. (Limited) against the owners of the London "Standard".

Mr. Rufus Isaacs, in opening the case, said the action was brought in respect of certain charges published in the "Standard" on September 28, 1908, under circumstances which had inflicted great pain on the plaintiffs, which reflected very seriously upon their character, and which were intended to convey grave imputations upon them.

Messrs. Cadbury were well-known in the manufacturing world, had a high reputation as a firm caring for the social welfare of their employes, *[sic]* and were pioneers in the promotion of garden cities in connection with their business. The plaintiffs were large buyers of raw cocoa, which they had to use in the preparation of their products. They bought their cocoa in the market, except for a small interest which they had in Trinidad. The cocoa plaintiffs used came from the islands of San Thomé and Principe, and it turned out to be obtained by what could only be described as forced labour, which constituted a condition of slavery.

The plaintiffs took steps to bring this to an end by not only threatening to refuse to purchase any more cocoa there, but by interviewing Sir Edward Grey and by bringing the matter under the notice of the Aborigines' Society and the Anti-Slavery Society; in fact (said counsel), they did everything honourable people could, and spent a large sum of money. Mr. W.A. Cadbury determined to go to San Thomé and Principe, and then appeared the libel. It was contained in the leading article which stated:—

We can only express our respectful surprise that Mr. Cadbury's voyage of discovery has been deferred so long. One might have supposed that Messrs. Cadbury would themselves have long ago

ascertained the condition and circumstances of those labourers and islands adjacent who provide them with raw material.

The article went on to say that other observers had anticipated Mr. Cadbury, and concluded:—

The slave does not seem to be tortured, and he is not starved, but he has no freedom. He is herded into compounds. (Think of that, Mr. Cadbury—compounds!) He works from sunrise to sunset. Worst of all, this slavery and slave driving and slave dealing is brought about by the necessity of providing a sufficient number of hands to grow and pack cocoa on the the islands of Principe and San Thome, the islands which feed the mills and presses of Bourneville. *[sic]*

Counsel contended that this amounted to a statement that the plaintiffs had not done what they had pretended to have done, whereas they had exerted themselves in every possible way to put an end to conditions of forced labour in those islands.

After counsel's address the court adjourned.

SIR EDWARD GREY AS A WITNESS.

Sir Edward Grey was called as witness on Tuesday. He said since he had been Foreign Secretary various representations had been made to him by Messrs. Cadbury in reference to the condition of native labour in St. Thome *[sic]* and Principe. He remembered an interview on October 26, 1906. His recollection was that Messrs. Cadbury asked for the interview because they had or were going to have some information dealing with slave labour in certain Portuguese possessions. Mr. W.A. Cadbury wished to consult him as to how that information should be dealt with. His recollection was that Mr. Cadbury asked him what would be the best course for him to pursue, and he replied that the best thing would be for Mr. Cadbury to send him the information and give him an opportunity of laying it before the Portuguese Government, and to give them an opportunity of acting upon it and inquiring into its truth. Meanwhile, he asked that Messrs. Cadbury should not make public use of the information or take any public steps with regard to it. His reason for doing this was that he foresaw if the information was published it would give rise to considerable feeling between this country and Portugal, and unless it was first communicated to the Portuguese

Government the immediate publication of it over here would be attributed to some political motive or other. The natural course would be to communicate with them first, and not to do something which would look like an attack upon their affairs. No memorandum was made of the conversation that took place, as he regarded it as a private interview, but a record was submitted to him by Messrs. Cadbury for his approval.

In cross-examination by Sir Edward Carson, Sir Edward Grey was asked whether negotiations with the Portuguese Government were still going on. He replied that the actual position was that the Portuguese Government had suspended recruiting in the colony, and, therefore, at the present time there was nothing more to be said between the British Government and the Portuguese Government. A number of questions and answers in Parliament on the subject of native labour in St. Thome *[sic]* and Principe were put to Sir Edward Grey for confirmation, but he stated that he was unable to do so. He accepted, however, whatever was in the documents.

Re-examined by Mr. Isaacs, Sir Edward Grey's attention was called to an answer he gave in Parliament to an inquiry as to whether he had recommended any firm who manufactured chocolate or cocoa in this country to continue to use for the present slave-grown cocoa, as by that means they were in a position to bring special pressure to bear upon the Portuguese Government. His answer was, "I have not advised any firms as to where they should buy their cocoa."

Mr. Isaacs asked to what period Sir Edward was directing the answer, and he replied that he took the words "For the present" to apply to the year 1909. The rights of interference by the British Government depended upon the treaty obligations existing between the two countries.

Mr. Isaacs was proceeding to ask Sir Edward Grey whether there was any truth in the suggestion that some private person could have had greater influence with the Portuguese Government than the British Foreign Office, when Sir Edward Carson suggested that that was a very embarrassing question to put to the witness.

EVIDENCE BY MR. W.A. CADBURY.

Mr. W.A. Cadbury was re-called, and was examined at length in reference to correspondence with various people at home and abroad with the view of steps being taken to put down slavery in the islands.

As to the interview with Sir Edward Grey, he said they had always felt that the matter was not a trivial thing that one private firm in England could handle. It was an international matter, and they had always gone to the highest authority for advice. He believed at that time that Sir Edward Grey seriously meant to do what he could. At the same time Sir Edward said they must keep quiet and make no public protest.

Witness said he told Sir Edward that if he at any time felt that their buying cocoa stood in the way of his action, he had only to say so. They were prepared to follow his directions and to stop buying cocoa. Sir Edward's reply was to the effect that for the moment at least they must just do nothing in the matter, but leave it to him. They were trying to do their best to back up the Foreign Office. The cost of sending out Mr. Burtt to make investigations was about £3,300. All the other cocoa firms were anxious to pay their share of the cost.

The examination of the witness had not concluded when the court rose.

'INSINUATIONS DENIED BY MR. W.A. CADBURY.'
The hearing was resumed on Wednesday when

Mr. W.A. Cadbury said in 1907, on behalf of the English cocoa manufacturers, he met a committee of the proprietors of the estates of San Thome and Principe. To this committee he said their consciences would not allow his firm to go on purchasing raw material unless assured that in future it was produced by free labour. When the Portuguese Ministry was changed, following the assassination of the King, he was informed that a Commission was going to the islands, and Sir Frederick Villiers, of the British Legation, said he had no doubt the new Portuguese Government meant to carry out the intentions of their predecessors. Witness said early this year the plaintiffs tried to get all the cocoa firms to refuse to buy San Thome and Principe cocoa. In October of last year he visited the territory, and was satisfied there had been no radical improvement. On his return the plaintiffs took steps to stop the purchase of San Thome cocoa. The last purchase of San Thome cocoa was in October, 1908. There was no truth in the allegation that the plaintiffs had been purporting to take steps, but had not been acting sincerely.

Cross-examined by Sir E. Carson, Mr. Cadbury said it was a fact that San Thome cocoa had been slave-grown to his own knowledge for eight years.

The cocoa you were buying was procured by the atrocious methods of slavery?—Yes.

Witness said the men, women, and children were taken away from their homes, possibly against their will, and marched various distances. He believed they were shackled at night. He did not consider the accommodation on the best estates at all bad.

Sir Edward Carson: Knowing slavery was atrocious you took the main portion of your cocoa from these islands?—Yes.

For some years you did not look upon it as anything immoral?—Not under the circumstances.

Witness swore the plaintiffs were not anxious to keep from the public knowledge of the conditions of slavery, and denied it was from fear the consumer would boycott the firm that they were anxious not to have the matter made public. If the public had known it might have been detrimental to the plaintiffs.

Witness denied the allegations that the action they took to improve the labour conditions was taken for the purpose of preventing attack on their character as philanthropists, to lessen public comment, or to postpone the final decision as to the non-purchase of cocoa from San Thome. They acted in all sincerity, and honestly thought no other steps could wisely have been taken to meet the existing evils.

In cross-examination by Sir Edward Carson, witness said the capital of Cadbury Bros. Was £2,000,000, but it was an unfair imputation to say that it was partly a philanthropic concern. His uncle, Mr. George Cadbury, was part proprietor of the "Daily News," but witness had no interest in that paper.

Witness added that when he first had reliable particulars of affairs in the islands, he thought it his personal duty to follow up the matter himself. The mortality among the natives made him realise that the matter would not brook delay.

The hearing was again adjourned.

*The Weekly Mail,* 4 December 1909, p1

## MESSRS. CADBURY'S LIBEL ACTION

There have been few more interesting libel actions than that which the Messrs. Cadbury brought against the "Standard" newspaper. In the result they obtained a farthing's damages, and the verdict is of a nature which we have become accustomed to look upon as contemptuous, as meaning that the plaintiffs do not deserve to succeed and have suffered no injury. On the other hand, the jury might reasonably have

thought that the costs of such an expensive action would in themselves form sufficient punishment to the defendants for having libelled the plaintiffs. It would be unfair in all the circumstances to interpret the finding of the jury as a verdict for the defendants, or as a reflection upon a firm whose reputation, whatever we may think of its politics, stands deservedly high. There can be no question as to the state of slavery that existed in San Thome and Principe. It was vile in the last degree, and Mr. W.A. Cadbury and Mr. Burtt, who was sent out by the firm to report upon it, did not attempt to deny it or to excuse it. They continued to purchase cocoa beans produced by this slave labour, but, on the face of the only evidence produced in the case, it can scarcely be upheld that this was done for financial gain. For all the time they were trying to put a stop to the gross system of slavery. There is no doubt that Messrs. Cadbury did a great deal more than many ordinary firms would have done to end it, but they were dissuaded from stopping purchasing their supplies on the advice of our own Foreign Office, surely the best that could be obtained. The advice may have been wrong. The Cadburys might have done more good for humanity if they had followed their first inclination and withdrawn their custom. However that may be, they accepted the advice and followed it, as we think, believing that it was best, and that the abominable state of slavery could be ended by other means.

*The Weekly Mail*, 11 December 1909

# Bibliography

## Books & further reading

Bradley, John, *Cadbury's Purple Reign: The Story Behind Chocolate's Best-Loved Brand* (John Wiley & Sons, Ltd, 2008)

Cadbury, Deborah, *Chocolate Wars: from Cadbury to Kraft: 200 years of sweet success and bitter rivalry* (Harper Press, October 2010)

Carrington, Iris (ed.), *Bournville: The Workers' Story* (Monks Bridge Books, 2011)

Chinn, Carl, *The Cadbury Story: a short history* (Brewin Books, September 2015)

Crosfield, John F., *A History of the Cadbury Family: Volume One,* 1985

Gardiner, A.G., *Life of George Cadbury* (Cassell and Company, 1923)

Phillips, Julie, *Birmingham at War* (Pen & Sword, 2018)

Simmons, Douglas A., *Schweppes: The First 200 Years* (Springwood Books, 1983)

Williams, Iolo A., *The Firm of Cadbury: 1831–1931* (Constable & Co Ltd, 1931)

## Periodicals

*Beverages and Foods News*

*Bournville Magazine*

*Bournville Reporter*

*Boys & Girls: News of your Favourite Books and Authors,* September 1956

*Cadbury Schweppes Special Report*

*Chambers's Edinburgh Journal,* 30 October 1852

*Foods Group News*

*Tea & Foods Group News*

*The Bournville Works Magazine* (later *BWM*)

*The Weekly Mail,* 4 & 11 December 1909

## Leaflets, booklets, pamphlets

*Barrow's Stores Centenary 1824–1924*

*Bournville Utilities: a War Record 1945*

*Bournville Works and The War 1914–1919*
*Cadbury: A Background to the Family and the Firm*
*Cadbury at Bournville: 1879–1979*
*Cadbury's: The Chocolate. The Taste. The story of Cadbury Limited*
*Cadbury's: The Chocolate. The Taste. The story of cocoa and chocolate*

## Online resources

http://www.bbc.co.uk *Landmark Cadbury's sign lowered from Somerdale factory*
https://blackminsterbusinesspark.co.uk *History of the park since 1900*
www.birminghammail.co.uk *32 things you might not know about Birmingham chocolate maker Cadbury*
www.birminghammail.co.uk *Meet Cadbury descendant planning to open chocolate factory in Birmingham*
www.cadbury.co.uk
www.cadburyworld.co.uk
www.ft.com *Case Study: Kraft's takeover of Cadbury*
www.telegraph.co.uk *Cadbury comes home as Dairy Milk production set to return to UK*

# About the Author

Diane Wordsworth is a freelance writer who has been writing stories, articles and books since 1985. Her work has appeared in local, national and international trade and consumer magazines and newspapers, and on local radio. Primarily a broadcast journalist, Diane has also edited and proof-read non-fiction books, novels, classroom resources and magazines. She lived and worked in Birmingham and Solihull before moving to Yorkshire in 2004, where she writes and edits on a full-time basis.

**Also by the author**

**Fiction**

*Night Crawler: a Marcie Craig mystery*

**Short story collections**

*Twee Tales*
*Twee Tales Too*

**Writers' guides**

*Diary of a Scaredy Cat: a year in the life of a frightened writer*
*Diary of a Pussycat: a year in the life of a freelance writer*

**Other non-fiction**

*Tales from Baggins Bottom: Best Bits*
*Tales from Baggins Bottom: Best Bits book 2*
*Tales from Baggins Bottom: Best Bits book 3*
*Tales from Baggins Bottom: Best Bits book 4*

# Index